Remembering

ST. PETERSBURG

Florida

Remembering
ST. PETERSBURG
Florida

VOLUME 2
MORE SUNSHINE CITY STORIES

SCOTT TAYLOR HARTZELL

Charleston London

History
PRESS

Published by The History Press
Charleston, SC 29403
www.historypress.net

Copyright © 2006 by Scott Taylor Hartzell
All rights reserved

Cover Image: As residents vie for victory in a grand match of horseshoes at
Williams Park in 1915, only rooftop seating remains.

First published 2006

Manufactured in the United Kingdom

ISBN 1.59629.122.2

Library of Congress Cataloging-in-Publication Data

Hartzell, Scott Taylor.
Remembering St. Petersburg, Florida : Sunshine City stories / Scott
Taylor
Hartzell.
p. cm.
Includes bibliographical references and index.
ISBN 1-59629-120-6 (alk. paper)
1. Saint Petersburg (Fla.)--History. 2. Saint Petersburg
(Fla.)--Biography. I. Title.
F319.S24H37 2006
975.9'65--dc22
 2006013545

Contents

Acknowledgements 7
Preface 9

The St. Petersburg Woman's Club: Ladies with Fortitude 13
Davis Academy: Sacrifice and Dedication 19
St. Petersburg: Soaring Into Aviation History 25
Walter P. Fuller: Bootlegging, History and High Finance 31
Dr. Johnnie Ruth Clarke: Grace, Intelligence and Compassion 37
Karl H. Grismer: Newspaperman, Editor and Historian 43
Dr. Ernest A. Ponder: A Struggle for Excellence 49
Dr. N. Worth Gable Jr.: Physician and Warrior 53
Margaret Acheson Stuart: The Heart of St. Petersburg's Art 59
The Florida Theatre: St. Petersburg's Palace 65
Gibbs High School: The Miracle on Thirty-fourth Street 69
Helen Dearse Roberts: St. Petersburg's Matron of Music 75
Albert Whitted Airport: Toiling Through History 81
Glen Dill: The Sunny Side of St. Petersburg's Mornings 87
R.W. Caldwell Sr.: Pinellas's Trusted Realtor and Politician 93
Thomas Dreier: An Idea's Best Friend 99
Dick Bothwell: St. Petersburg's Bundle of Joy 103
The James Weldon Johnson Branch Library: The Dawn of 109
 True Freedom
James Rosati Sr.: The Duke of Construction 113
Norman E. Jones: A Voice of Controversy 117

Selected Bibliography 123
Index 125

Acknowledgements

W ith sorrow I would like to thank former residents Charles Kannis, John Thornton and Don Saxer, who have passed on, taking with them their cherished reminiscences of the Sunshine City. Numerous other individuals and institutions contributed to the completion of *Remembering St. Petersburg, Florida, Volume II: More Sunshine City Stories*.

I would like to thank the *St. Petersburg Times* and its research staff for allowing me access to its archives. *Times* editors Sandra Gadsden, Kevin McGeever and Jim Verhulst provided endless advice and direction while I completed more concise versions of the stories for the *Times* that may also be featured in *Remembering St. Petersburg*. Much appreciation is extended to the St. Petersburg Museum of History, which supplied me with unlimited reference material and many photographs for the book. Thanks to Will Michaels, Jessica Ventimiglia and Ann Wikoff and her team of volunteers, who lent research and technical assistance to my writing efforts. Special thanks to museum volunteers Bill Watts and Marta Jones. Endless gratitude goes out to the main branch of the St. Petersburg Library. Its reference personnel included JoAnne Balistreri, Joe Brady, Harriet Johnston, Patty Hay, Alice Hoeft, Anne McEwen, Sarah Thogode and others who pleasantly directed me to masses of information.

I am indebted again to former *Evening Independent* reporter Bethia Caffery for her unlimited help, advice and inspiration. Many residents supplied photographs for the book; many more provided their personal reflections. Assisting my efforts were Don Addis, Burton Allen, Don Allen, Mary Wyatt Allen, Violet Atkins, Paul Barco, Nancye Barrett, Betty Barrs, Donna Farmer Benjamin, Alyce Bennett, Iveta Berry, Genevieve Binda, Mr. and Mrs. Robert DeVoe Blanc, Sam Bond Jr., Lynne Brown, Bill Buston, R.W. Caldwell Jr., Mary Campbell, Sydney Campbell, Angres Chapman, Cathlene Clarke, Michael Clarke, Peter Clarke, Ernie L. Coney, Billy Cooper, Lon Cooper, Charles Louie Crawford,

Leigh Dallas, Helen Dann, Martha Long Dann, Phillip W. Dann, Henry Davis, John Dennis Jr., Mary Shenk Dodd, C. Fred Duel, William Gray Dunlop, Mary Evertz, Willie Felton, Ernest Fillyau, Mary Gaines, Allison Gunther-Blackman and Bob Haiman. Also thanks to Elizabeth Haslem, Sydney Hilliard, June Bothwell Hinson, Ella Mary Holmes, Joseph Holt, April Caldwell Hornsleth, Paul Hornsleth, Chuck Horton, Paula Ivory, Donald M. Jackson, Kevin Johnson, Norman E. Jones II, Dr. Karl M. Kuttler, Laura Labadie, Byrd Latham, Jo Ann Maloney, Maxine Lee, Marilyn Latham Mathis, Bernice McCune, Roberta McQueen, Bill Mills, Bridget Misner, Marvin Mosher, Fay Mackey Nielson, Helen Gandy O'Brien, Rosalee Peck, Shirley O'Sullivan, Hank Palmer, Peggy Pennington, Peggy Peterman, Pamela Peterson, Betsy Pheil, Clara Ponder, Carol Presti, Jack Rankin, Robin Reed, Dennis Rhodes, Mary Richmond, Jim Robinson, Joseph Rosati, James Rosati Jr., Minson Rubin, Helen Rudolph, Jim Schnur, John Schuh, Perkins T. Shelton, Peter Sherman, Barbara Shorter, Rebecca Stern, Harriet Strum, Chrystelle White Stewart, Emanuel Stewart, Chip Harvey Sullivan, Dan Sullivan, the Reverend Wayne Thompson, Jeanne Sullivan Tucker, Joan Appleyard Tucker, Jim Turner, Joanne Walker, Mordecai Walker, Sheri Weaver, Jeannie Weber, Nathan White, Fred E. Wilder, Fritz Wilder, Jon Wilson, Dr. Eric Whitted and June Hurley Young.

Endless gratitude is extended to my former instructors at the University of South Florida, St. Petersburg. Professors Mike Killenberg, Robert Dardenne, Jay Black, Keith White and Herb Karl were marvelous critics of my student endeavors.

My apologies if I have overlooked anyone.

Preface

In many ways, *Remembering St. Petersburg, Florida, Volume II: More Sunshine City Stories* serves as a warm friend who is always there to introduce you to whom or what you may not know about the city. On the other hand as you travel through its pages, the work may reacquaint you with someone or something else from the Sunshine City's history. Either way, I think you will learn more.

By 1913, a quarter of a century after the arrival of the Orange Belt Railroad in St. Petersburg, the sun had failed to shine on any hope for the equality of all the city's residents. Blacks were restricted to the bleak neighborhoods of Cooper's Quarters and Pepper Town—communities south of Central Avenue blanketed with unpaved streets and decrepit shacks owned mostly by white absentee landlords. Blacks did have their choice of jobs, however, as long as the work was menial, grueling and low paying. Black labor had helped to bring the Orange Belt Railroad to St. Petersburg, and it was now needed to build the Sunshine City. Change, albeit minute, surfaced in 1913 with the opening of Davis Academy. The academy stood tall as St. Petersburg's first black school, but it was a glaring example of the city's somber definition of educational equality. The experience was a seed, however, that grew to brighten the eyes and minds of black children. Future black leaders emerged: Cora Huggins, J.W. Ovaltree, Emanuel Stewart, O.B. McLin, Ernest Ponder and Dr. Johnnie Ruth Clarke. Gibbs High School, the city's first black high school, and the James Weldon Johnson Library, the city's first black library, followed. *More Sunshine City Stories* brings to life the accomplishments of Ponder, Clarke and Norman E. Jones and details the positive impact that Gibbs High School and the Johnson Library had on the black community.

Alongside these accounts are the details behind the success of the St. Petersburg Woman's Club. North of Central Avenue in 1913, this

team of vibrant women led by Illinois native Nancy Greene banded together to fight poverty, enjoy music and demand bakery cleanliness. The women's unselfish labor and unending drive caused developer C. Perry Snell to call the group "the city's strongest and most important organization." Later in 1914 when Percival Elliott Fansler realized his dream, St. Petersburg made aviation history. Wide-eyed residents flocked to the waterfront that New Year's Day to watch twenty-four-year-old Anthony Habersack Jannus pilot the first paid, scheduled passenger flight in the world. Spectators clapped and cheered that Sunday; others bet that Jannus wouldn't be able to lift his flying boat and passenger former Mayor A.C. Pheil off the ground.

Beginning in the early 1920s, the articulate and humorous historian Karl H. Grismer kept the nation abreast of the Sunshine City's activities in the *Tourist News*. Grismer wrote for and edited the slick publication that enticed tourists to St. Petersburg. In 1924, Grismer introduced the city's past to readers in his *History of St. Petersburg*. After completing several other American city histories, Grismer returned here and penned a 1948 update of the Sunshine City's times gone by. Grismer's second eloquent and accurate chronicle of our past is perhaps unequaled.

After Dr. N. Worth Gable Jr. battled Mexican revolutionary Francisco "Pancho" Villa near the Mexican border, he established his medical practice here. Residents of St. Petersburg also revere Gable as the founder of the city's first National Guard unit.

Beginning in 1929, the art and music scene of St. Petersburg was enhanced by two elegant women. Helen Dearse Roberts spent much of her time benefiting local charities and hospitals. The greatest footprint she left here, however, was the establishment of music clubs and symphonies and the financial support she rendered to them. Former Mayor Herman Goldner once praised Roberts by telling her publicly that "[St. Petersburg] is a better place because you live here." The St. Petersburg Museum of Fine Arts owes its very existence to the Sunshine City's matriarch of art, Margaret Acheson Stuart. Before establishing the institution here Stuart visited museums throughout the world, often while idle during train stops. It was Stuart's love of art, her unselfish labor and her more than one-million-dollar gift to the city that brought life to the Museum of Fine Arts.

If asked to cite two historically significant structures from our city's past, many longtime residents would point to the Florida Theatre and Albert Whitted Airport. For forty-one years the Florida Theatre was like a best friend to St. Petersburg denizens, offering them an escape from life's drudgery and painting smiles on their faces with vaudeville,

concert and film. A wave of despair flowed through the city when the Florida was demolished. Since its opening in 1929, Goodyear blimps and National Airlines and a plane that resembled a bat have been a part of Albert Whitted Airport's history. Beginning more than five decades ago, however, various politicians and developers have questioned the airport's waterfront value and a battle has raged that has threatened Albert Whitted's very existence.

Gags, stunts and slick routines were a huge part of the lives of radio broadcaster Glen Dill and *St. Petersburg Times* journalist Dick Bothwell. Dill's morning show on WTSP attracted listeners inside the city's limits, across the country and throughout the world. The Cleveland native received some three hundred thousand fan letters, some of which were hand-delivered to him by swooning teens. Other listeners sent Dill anonymous gifts. As a *Times* weatherman, Bothwell coined such phrases as "expect a blanker grabber of a night." Readers loved Bothwell's warm approach and his creations, J. Thundersquall Drip and Pelican Pete. Bothwell later entertained many with several books and public speeches. Bothwell's death brought clouds of sadness over the Sunshine City.

In the early 1940s R.W. Caldwell Sr. founded the St. Petersburg Multiple Listing Service, Inc., which allowed realtors in St. Petersburg and Gulfport to share data regarding customers and available homes. Real estate sales increased, and Caldwell continued to advance Gulfport and improve its relationship with St. Petersburg as the president of the St. Petersburg Board of Realtors. To improve St. Petersburg's literacy, Thomas Dreier gave undying support to area libraries. A self-proclaimed vagabond and a pagan, Dreier helped establish St. Petersburg's main library system and the Friends of the Library while authoring nine books. In 1950, developer James A. Rosati Sr. led St. Petersburg out of a Depression-inspired dry spell in home construction that had stagnated over the city for some two decades. Perhaps his most prized tribute occurred in 1960, however, when Rosati netted the Award of Merit for his Horizon Home for the Disabled from the American Institute of Architects. Writer Lynn B. Clark of *Women's Day* magazine said, "Rosati is...the unchallenged retirement home producer of the Florida West Coast."

As *More Sunshine City Stories* travels with you into the lives of these former residents, it will endear you to the city's past.

The St. Petersburg Woman's Club: Ladies with Fortitude

The Woman's Club is one of the city's strongest and most important organizations.

Developer C. Perry Snell

In 1929 after sixteen years of meeting in churches and hotel ballrooms, members of the St. Petersburg Woman's Club found a home. Before the building's November dedication the women positioned a galaxy of lanterns outside the clubhouse. Rays of light danced off Coffee Pot Bayou, raced back to their source and lit the path to the door. Inside, lanterns illuminated rooms and hallways; the auditorium sparkled in radiant beauty. "The roomy stage in the auditorium was banked with palms and ferns, with large baskets of yellow chrysanthemums and quantities of white flowers in front of the beautiful Spanish chairs," the *St. Petersburg Times* wrote. The event commemorated the dawn of a dazzling future for the St. Petersburg Woman's Club.

Before the women had acquired their Snell Isle clubhouse and hung those lanterns with pride, however, they had become the first state club to support the World War I relief effort. They had championed civic responsibility and helped form the local Red Cross and YWCA. Today, after decades of dedication to the community, the Woman's Club boasts nearly two hundred members. "The group is an umbrella of every cause in the community," said Joanne Walker, club president from 2002 to 2004. Fay Baynard, club president from 1992 to 1994, called the organization "a very caring group of women whom have worked hard to improve the lives of working people."

The roots of the St. Petersburg Woman's Club were planted in 1913, as Congress was debating the implementation of a federal income tax and actor Mary Pickford was brightening the big screen. Evanston, Illinois native Nancy Greene had arrived in St. Petersburg and was conducting

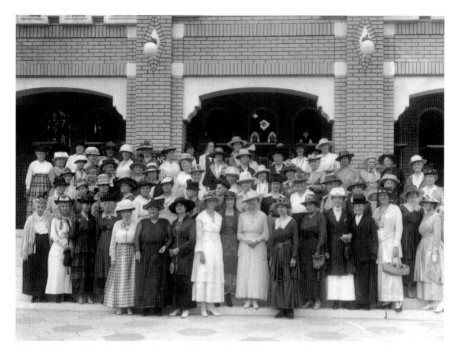

The ladies of the St. Petersburg Woman's Club pictured in 1919. By then they had helped foster the local Red Cross and the YWCA. *Courtesy St. Petersburg Museum of History.*

lectures on the Mormon faith. After her popularity blossomed, Greene asked 13 of St. Petersburg's 4,127 residents to join her to fight poverty, enjoy music and demand bakery cleanliness. At the First Baptist Church on February 7, 1913, Greene called to order the premier meeting of the St. Petersburg Woman's Club. "The object is to instruct and entertain, and to follow along the lines prescribed by the General Federation of Women's Clubs, and shall meet every Thursday afternoon at three o'clock at the First Baptist Church," read the minutes of that first meeting, now preserved at the St. Petersburg Museum of History. "One dollar dues shall be required of all members excepting local minister's wives, who shall be honorary members." Greene was elected president of the group, and other official positions were filled. The women then conducted a profound discussion of the book *Spirit of Youth in the Street* by Jane Addams. Music filled the air.

At a March meeting, an orangewood gavel became an integral part of the group's monthly gatherings. The club continued meeting at various churches, focusing on immigration, women's suffrage, child labor and Bible study. It gave 10 percent of its income to civic and charitable

causes. In 1913, the group joined the Florida Federation of Women's Clubs. Two years later the ladies were honored for their World War I Belgian relief work. By 1919, the women had helped foster the local Red Cross and the YWCA. Said former club President Baynard in a 1993 speech about that time: "Women gained the right to vote in 1920, but people are still spitting on the sidewalks." In 1922, the organization's four hundred members under president Hulda Slayton established a clubhouse-building fund. Within six years it had amassed $11,000, and developer C. Perry Snell had offered the group property at Forty Snell Isle Boulevard Northeast. Members balked; the property sat far from the trolley, and access was limited to a one-lane, unstable bridge. On December 24, 1928, however, the women accepted the property and thanked Snell. "On learning of the needs of the club I was much pleased to make the gift of the two lots," the *Times* reported Snell saying that day. "I know, as many others do, that the Woman's Club is one of the city's strongest and most important organizations, doing admirable work in the upbuilding of St. Petersburg. I am more than glad to make a gift of the ground whereupon will be erected a home in which the club can expand and enlarge its active and worthwhile energies."

On November 4, 1929, members dedicated their $30,490 clubhouse designed by Frank F. Jonsberg, architect of the Princess Martha and Jungle hotels. The Mediterranean-style, cream-colored structure covered an area 106 by 80 feet. It boasted a kitchen, a film projection room and an auditorium that seated six hundred. Speakers that evening included Mayor Judge Arthur Thompson. An array of yellow chrysanthemums highlighted the stage. Members praised Snell and the crowd sang the first song ever in the new home, "The Star Spangled Banner," and a new Florida state song was unveiled. "A fitting culmination of 16 years of patient work and sustained hope for a Woman's club house," the *Times* wrote then. "An occasion of importance to prominent club women from all over the state."

A decade later, however, club President Mildred Blake unleashed a sour message to the *Times*. "Although the clubhouse was furnished as to furniture—the kitchen was largely unequipped, the grounds were in a chaotic condition and there were no bylaws to govern the functioning of a clubhouse and no plans established for maintaining the property." By 1932 after numerous consultations with other groups regarding proper organization, order had improved and furnishings had been acquired. The Garden Club had beautified the grounds and the Woman's Club had inspired the construction of a new Snell Isle Bridge, which opened on Christmas Day 1931. During the Depression, however, paid

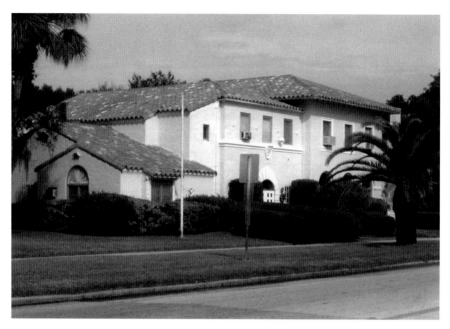

On November 4, 1929, members dedicated their $30,490 clubhouse designed by Frank F. Jonsberg—Princess Martha and Jungle Hotel architect. Above is a 2002 picture of the clubhouse. *Courtesy St. Petersburg Museum of History.*

membership plummeted from 149 members in January 1932 to 81 in 1933. The group lost about $800 in the first of two bank crashes. After the Depression had eased slightly in 1939, membership leaped to 366.

On April 18, 1940, the Woman's Club held a ceremony to burn the clubhouse mortgage. One month later, on May 24, a blaze in an unfinished room above the kitchen forced major repairs. "Energetically, (members) went to work, and by the fall opening the Club was repaired and remodeled with new equipment and furnishings," a Woman's Club history reads. "The second-floor apartment [was] readied, a central heating system installed and the sliding platform put under the stage." In the 1940s the club sang "Praise the Lord and Pass the Ammunition" and sold war bonds to support the war effort. Members supplied Wildwood and Jordan Parks with playground equipment. In the 1950s a choral group formed, and great benevolence followed. Members gifted a fireplace to the Girl Scouts, scholarships to the Seminole Indians and equipment to the Kathryne Payne Rehabilitation Center and Mound Park Hospital (today's Bayfront Medical Center). Meanwhile, membership soared to 788. "There were so many members they were seated in the balcony," said Bernice McCune, club president

from 1967 to 1968. After financially supporting Radio Free Europe in 1960, the Woman's Club earned a plaque honoring it as the most prolific fundraiser of the Florida Federation of Woman's Clubs. The Vietnam War, civil rights issues, Watergate and President Richard Nixon's resignation deeply scarred the nation and the club in the 1960s and 1970s. During that period, the Woman's Club membership dropped to 400. In 1989, the clubhouse was named a local historical site. "(Council's) vote was unanimous and everyone was ecstatic," said Vera Brantley, club president from 1988 to 1990. "It enhanced the prestige of the organization." A year after becoming a state landmark in 1993, the clubhouse was placed on the National Register of Historic Places. "There is something special about having such a historical building as a clubhouse," said former club President Walker, under whom the group aided hospice and the Sallie House financially. "Each member has a good heart, serves the community and makes friends."

In August 2004, the club reached out to young women age twelve to eighteen and established the St. Petersburg Juniorette Club. The Juniorettes currently boast some twenty members and have become incorporated as the Florida General Federation of Woman's Clubs St. Petersburg Juniorettes. "The girls are our hope for the future," said Walker, the girls' advisor. In 2005, under the leadership of President Rebecca Stern, the Woman's Club worked to realize their theme of "Build a New Foundation." It has worked with the IRS to achieve a 501C3 tax status, which allows individuals to declare as tax exempt any of their donations to the Woman's Club. The tax status would enable the group to qualify for historical and education grants. At one point, the Woman's Club donated more than fifty-four thousand hours to the community. "We're going to continue to give back to the community," Stern said.

Davis Academy:
Sacrifice and Dedication

Davis dreamed big dreams, preparing you for the next level. They had our heads in the sky each day.
> Former Davis student Sidney Campbell

As one story goes, the name for Davis Academy flowed from a Northerner named Ned Davis. Very much a compassionate man, Davis appreciated the goals the school touted in 1914 before it opened as the city's only learning institution for black children. "Yes we were the only black school, and I had excellent teachers," said Roberta McQueen, a Davis Academy student in the 1920s who also taught there from 1943 to 1967. "I taught wherever they needed me. We had very sorry supplies. But that's all right. We made it."

Sacrifice and dedication allowed Davis Academy to serve until prejudice eased slightly, allowing more black schools to open in the mid-1920s. At that point Davis Academy became Davis Elementary. The school struggled into the 1960s while instilling pride and brilliance in the majority of its students. "Often teachers walked dirt roads knocking on doors and asking for funds," the *Evening Independent* wrote in June of 1967. "Many times they taught the final month with no remuneration." Said Sidney Campbell, a Davis Elementary student from 1934 to 1940: "Davis dreamed big dreams, preparing you for the next level. They had our heads in the sky each day."

In 1911, pioneer developer and road builder James Cribbett donated less than an acre at Third Avenue and Tenth Street South to the school board. Davis Academy opened there in 1914 with J.W. Ovaltree as its principal. To this day, the school's namesake remains uncertain. "[A] man who came down from the north...took a great deal of interest in the school," former black school superintendent Henrietta Dominis speculated in 1967. "His name was Ned Davis." The *Independent* reported

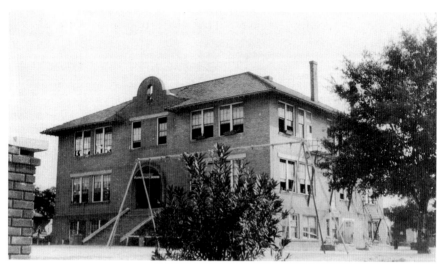

At 950 Third Avenue South, Davis Academy stood three stories high and sat on a concrete foundation—much like the solid base upon which rested its caring and determined instructors. *Courtesy St. Petersburg Museum of History.*

in June of 1967 that historian Walter P. Fuller had a different take on the school's naming. "Walter P. Fuller says the school surely must have been named for pioneer F.A. Davis, who gave the city its first electric company, its first trolley line and its first advertising program in the 1900s. Sometimes 'Mr. Davis' brought tourists to the school to see a program and they always made a contribution."

At 950 Third Avenue South, Davis Academy stood three stories high and sat on a concrete foundation—much like the solid base upon which rested its caring and determined instructors. The structure housed fourteen classrooms, a library, a kindergarten, small offices, a store, supply rooms and a clinic—a partitioned half of a classroom. The Academy's walls were sixteen inches thick, just broad enough to keep the love in and the prejudice out. In reality, however, the Davis opening was a belated attempt to showcase a nonexistent equality between the races and an incomplete measure designed to pacify black parents. No more than a sixth grade education was available at the Academy, and black St. Petersburg high schools were nonexistent. It was a step forward, however, said Peggy Peterman, former *St. Petersburg Times* reporter and columnist. "Davis was very important because this was the beginning of segregated schools as far as African American students were concerned. The teachers were very intense about their students. They would tell the children that they would have to be ten times better than white students

in this society. The school had a reputation for a high level of excellence. You couldn't just spell. You had to excel."

For six months out of every year, Davis Academy operated with the barest of academic essentials. The students performed singing and recitation programs at Williams Park to raise funds to pay teachers and stay open additional months. After each performance, a collection plate was passed through the crowd. Space was so limited at the school that from eight a.m. to two p.m. the city closed part of Tenth Street to increase recreational space for the students. About 1922, Davis Academy student Paul Barco began walking two miles each day to the mountain of stairs that led to the overcrowded school's second-floor front entrance. "Students were even taught in the basement (first floor)," Barco said. "We were like sardines in a can. My first-grade teacher was Miss Bimbow, a mulatto. She kept order and attempted to acquaint us with learning. Someone came at lunchtime and sold peanuts and (five-cent) cinnamon buns. They were most delicious. We washed them down with water. In second grade, others and I were moved to Dandy's Church at Twentieth Street, between Ninth and Eleventh Avenues (to lessen crowding)."

Ella Mary Holmes, a former Davis Academy student and in 1938 a teacher there, said the areas that the school drew its students from were vast. "All of the children on the north side, the south side and the country (west of Sixteenth Street) went to that school," said Holmes, who recalled the huge wrought-iron fire escapes that protruded from the building's sides. Finally in 1925, Davis Academy enrollment was reduced when Jordan Elementary School opened. "Regardless of where they lived, all African American students went to Davis or Jordan Elementary," said Emanuel Stewart, a Davis principal from 1956 to 1957. "We set our own [boundary] lines, and it worked out pretty well."

In 1928 Gibbs High School opened, and Davis Academy became Davis Elementary. Prior to Gibbs's opening, St. Petersburg failed to offer a public high school education to blacks. The parents of black students had to enroll their children in private schools or black colleges that offered high school courses—if they could afford it. "Most black kids became workers and got a straw hat and a pair of boots," Barco said. From 1934 to 1940, future Sixteenth Street Jr. High School instructor Sidney Campbell enjoyed his first educational experience as a Davis Elementary student. He recalled the contests and candy bar sales that boosted school funds and illustrated the cohesiveness of the black community. Many teachers made and sold candy apples. "We were thirsty for information," Campbell said, "and the teachers fed us what we needed. They could orchestrate a lesson. My first-grade teacher,

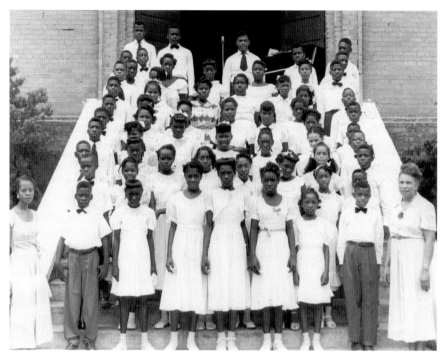

Students gather for Davis Elementary School Class Day in 1922 on the structure's steps. *Courtesy St. Petersburg Museum of History.*

Cora Huggins, became a legend. She taught every student. You couldn't move up unless you went through Miss Huggins. And there was Mrs. Booker. She ruled with an iron fist and a kind heart. A stately lady. We were all treading the same pathway, and we all knew everyone. There were many things that weren't funded, but we wouldn't have fallen out of the game over something we didn't have."

In 1952 Davis Elementary almost closed, but improvements were made after a $10,000 acquisition that enabled the school to remain open another fifteen years. Former students Roberta McQueen and Irene Beasley, who earned $60 a month when they began teaching at the school in 1943 and 1930 respectively, were still teaching there in 1967 when Davis Elementary closed that summer. They and the remainder of the school's teachers under contract went to other local institutions. William G. Thompson closed out his eleventh year at Davis Elementary and his ninth year as its principal. "I will put [Davis] up against any school in the county when it comes to meeting the needs of its pupils," an *Independent* article in June 1967 quoted Thompson, who after the closing moved on to the St. Petersburg Special Education Center. "[It's]

not the building, but what goes on in the building. Our children measure up to the other children in spite of the low economic conditions in which they are reared. This is the one thing we glory in." Davis Elementary, however, had seen better days. Age and lack of proper funding had led a state survey team to call the school "unfit for occupancy," according to the *Independent* in March 1967. Joseph Gibson, then director of pupil accounting, labeled Davis Elementary "antiquated and inadequate" in the same article. He said the team reported to him that the school should have a "capacity of zero." Woodlawn Elementary at Sixteenth Street and Seventeenth Avenue North absorbed 100 Davis Elementary students; Campbell Park Elementary at 1101 Seventh Avenue South took in 220 of the former Davis pupils. In September 1968, the property was sold to the St. Petersburg Housing Authority for $40,000. A public housing complex, Graham Park & Rogall, now stands where Davis Elementary served.

St. Petersburg:
Soaring Into Aviation History

Tony is a hero, yet only his flashing smile shows that he appreciates the plaudits.

Percival Elliott Fansler

In 1913, Percival Elliott Fansler envisioned boats with wings dotting the sky as they transported people from St. Petersburg to Tampa. It was a high-flying aspiration that led the speedboat enthusiast to look skyward and say two magic words: commercial aviation. Fansler then collected several prominent local businessmen to help him catapult his idea and air transportation into the future. At first the businessmen balked. "In St. Petersburg I had a very interesting reaction from the leading businessmen I interviewed," Fansler wrote in *Aero Digest* in 1929. "They thought I had a mighty clever idea, but they didn't believe there was any such thing as a flying boat. I talked a group of a dozen into putting up a guarantee of $100 each, and the Board of Trade [Chamber of Commerce] 'came in' for a like amount. Before me is the frayed sheet bearing the signatures of those men who backed the first commercial airline in the world."

Bridge builder George "Dad" Gandy and newspaperman Lew B. Brown appeared on Fansler's list. Also involved were developers C. Perry Snell and Charles A. Hall. Realtor Noel Mitchell, father of the orange and later green benches, jumped onboard. A farsighted L.A. Whitney represented the Board of Trade. Each benefactor agreed to pay Fansler fifty dollars, minus the passenger's fare of five dollars, every day in January 1914 that four scheduled trips were made between here and Tampa. Fansler hired pilot Anthony Habersack Jannus, age twenty-four, of the Benoist Aircraft Company in St. Louis. Fansler called Jannus a handsome devil, a talented flier and always full of ginger.

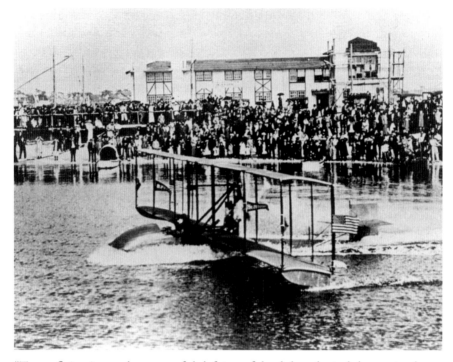

"To me flying is not the successful defying of death but the indulgence in the poetry of mechanical motion, a dustless, bumpless fascinating speed," said Anthony Jannus, pictured above in his airboat. *Courtesy St. Petersburg Museum of History.*

Like Fansler, Jannus believed that flying boats would enhance waterfront property just like automobiles electrified the city's suburban area. The sky was the limit, and Jannus loved the adventure and danger. "To me flying is not the successful defying of death but the indulgence in the poetry of mechanical motion, a dustless, bumpless fascinating speed," he told the *St. Petersburg Times* in 1914. "[Flying] is an abstraction from things material into infinite space. An abandon that is yet more exciting but less irritating than any other form of mechanical propulsion."

On December 30, 1913, at 4:47 p.m., the airboat that Fansler had acquired from Tom Wesley Benoist's company in St. Louis arrived via car No. 65033 of the Atlantic Coast Line Railroad. Jannus assembled the Model 14-B craft that afternoon on the waterfront sand, attaching the skids first, followed by the wings. The $5,600 airboat's wingspan measured forty-four and a half feet, while the largest airliner's wingspan today stretches nearly one hundred yards. Jannus's craft had two open

cockpits and a Roberts seventy-five-horsepower, six-cylinder engine that hiccupped and coughed. Fully assembled the craft weighed one thousand pounds, weightless compared with today's one-million-pound Goliath jet liners that cost $12 billion. "I was swimming with a friend when we saw Jannus assembling the plane," Luther Atkins, a future musician and city historian, told the *Times* in 1983. "We hung around until [Jannus] asked what we were doing, and we told him we were looking for a job. He handed us a can of axle grease. We were supposed to get paid with a ride, but we never got it."

That New Year's Day 1914 about 9:30 a.m., Atkins was spreading axle grease on a Municipal Pier ramp near Jannus's Benoist No. 43. Captivated by Jannus, the airboat and the crowd of three thousand, several fishermen interrupted their activity. Music added spice to the event, compliments of an Italian band belonging to Johnny Jones whose carnival was entertaining the city that week. Many amid the crowd were wagering that Jannus would fail to lift the airboat from the water. "More than half of the people in that crowd were sure he'd never make it," Charles Farling told the *Evening Independent* in 1966. Farling was eleven years old that New Year's Day. "I remember hearing some men bet on how far he'd get, and only one or two were willing to bet the whole trip. I can remember waiting for the plane to fall into the water. I wasn't particularly excited or scared. I was just darn sure it just wasn't possible to go through the air like that."

As the ceremony proceeded, several dignitaries addressed the crowd. Whitney spoke briefly, according to the *Times*, and then introduced Fansler, who was anxious to see his vision of commercial aviation come to fruition. "The airboat line to Tampa will be only a forerunner of great activity along these lines in the near future…what was impossible yesterday is an accomplishment of today—while tomorrow heralds the unbelievable." Jannus had but time for a few words before F.C. Bannister announced the beginning of the auction to determine the flight's first passenger. Former Mayor A.C. Pheil exchanged bids with Thornton Parker, Mitchell and Whitney as Bannister cried the auction. Pheil, who had talked about the flight with his wife Lottie all week, won the honor for $400. At 10:00 a.m. that Sunday, Jones's band played "Dixie" as handheld and motion picture cameras labored. The Benoist slid down Atkins's greased ramp into the central yacht basin, then sped away when reaching fifteen feet into the air. Spectators raced to the telegraph to grab word of Jannus's Tampa arrival. During the flight, chilling winds whistled through the plane. When an engine chain escaped the propeller shaft and forced the airboat into the drink, both men went to work on the repair. "My grandfather arrived in Tampa with grease all over his hands," Betsy Pheil said.

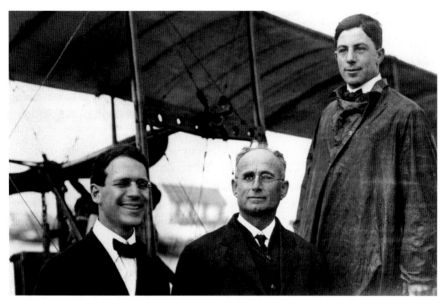

The men of the first flight: Percival Elliott Fansler, A.C. Pheil and Tony Jannus. *Courtesy St. Petersburg Museum of History.*

Amid a cheering Tampa crowd, the twenty-three-minute trip concluded. Pheil took the liberty to order supplies for his Pinellas Dredging Co. while there. Twenty minutes after leaving Tampa, Jannus—wearing a bow tie, blue coat and white trousers—landed back here at 11:20 a.m. Fansler later recalled the Benoist's arrival, reported the *Independent* in 1944: "The watchers see the speck in the eastern sky, and see it grow in size. Tony's not flying high. He's circling the basin to settle into one of his characteristic landings. He's driving up the ramp, and the crowd is going wild. Tony is a hero, yet only his flashing smile shows that he appreciates the plaudits." The Benoist had consumed ten gallons of gas and one gallon of oil on its thirty-six-mile historical flight. It had surpassed the efficiency of other transportation modes: steamboat, two hours; car, six hours; train, twelve hours.

Amid the excitement, Judy Bryant raced through the roped-off area to ask Jannus if she could have his cracked goggles. The aviator handed the ten-year-old his pair, along with a Benoist pennant. Both items are displayed today at the St. Petersburg Museum of History. Near Jannus that day, a raincoat-clad Pheil and humorist Will Rogers made a historic acquaintance, which initiated a friendship that resulted in occasional dinners and numerous postcard exchanges. Betsy Pheil said that Rogers told her grandfather that day that he hoped he could

someday do what Pheil had done; Rogers died in 1935 at age fifty-five in an Alaskan plane crash.

During a second auction, Mitchell prevailed with a $175 bid. Mitchell paid another $25 to cruise over the basin. Jones also took a $15 trip that day, which he said was novel and thrilling. The showman said he would have made Pheil pay more for the first flight if his carnival would have had more visitors that week. St. Petersburg's day in aviation history garnered $615, which went mostly to new harbor light construction. On January 2, Mae Peabody of Dubuque, Iowa, became the first woman to travel aboard the new airline. Fansler's line later expanded into Sarasota, Bradenton and Tarpon Springs. It transported more than twelve hundred passengers without a hitch before its contract expired three months later. "Wars in Mexico and Europe, a new St. Petersburg railroad, money panics and our preparation for entrance into World War I seemed more important than continuing the flirtation with aviation history," editor Bob Stiff of the *Independent* wrote in 1982. The later exploits of the Benoist are draped in mystery. One story claims that the airboat was sold to local flight enthusiast Bird Malcolm Latham in 1914 and suffered destruction after plunging into Pennsylvania's Conneaut Lake. A second story says that Jannus's brother, Roger Jannus, took the Benoist to California. Tony Jannus later flew for Curtiss Aeroplane Co., and in 1916 he died at age twenty-seven after crashing into the Black Sea. Pheil died of cancer in 1922. He was fifty-five. Mitchell battled alcoholism and died a penniless man in 1936 at age sixty-two.

Walter P. Fuller: Bootlegging, History and High Finance

The first bootlegger I ever met was me.

Walter P. Fuller

In 1907 at age thirteen, Walter P. Fuller closed a land deal that profited him $1,000. "That taught me a lesson I never forgot," he told the *St. Petersburg Times* in 1972. "There's money to be made and sometimes very quickly in real estate, and when you're in real estate, you're likely to get into a lot of other things and I certainly did."

Fuller also flourished as an author, politician, publisher, journalist, historian, financial consultant and football coach. He owned almost six thousand acres countywide. Fuller and his father managed eleven corporations, including three hotels, the power company, the first streetcar line and a boat line. "He did not lose an opportunity," former *Evening Independent* journalist Bethia Caffery said. "He was a survivor, had the aura of aristocracy but never looked down on anybody. Fuller was charming and funny, hardworking and manipulative. He could play the game no matter what the rules were." Fuller owned the Gangplank Nightclub, the Jungle Prada Shopping Center and the precursor to WSUN radio. He built the Jungle Country Club Hotel, today's Admiral Farragut Academy. Fuller constructed fourteen hundred homes and paved sixteen miles of St. Petersburg streets. He achieved millionaire status three times. "Walter Fuller was a man who loved business and politics," the *Times* wrote in 1973. "[He] knew to succeed in both one does not need to be untrue either to others or to yourself."

On April 6, 1894, Walter Pliny Fuller was born into economic hard times in Bradenton, Florida. Hard work outside his eighth-grade schoolroom allowed him to buy three lots for $30 down from his father, H. Walter Fuller, enabling the family to replace their broken stove. Fuller then worked various jobs to make his remaining $6 monthly

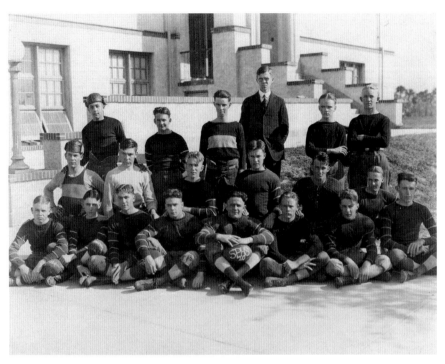

Fuller (rear) received twelve dollars weekly as St. Petersburg High School's first paid coach. *Courtesy St. Petersburg Museum of History.*

lot payments to his father. After buying four more lots for $500 and improving them with fences, trees and vegetables, he sold them for a $1,000 profit. Later at the University of North Carolina in 1911, he had an office with a secretary and drove a 1910 Hudson sedan while playing football and studying law, journalism and government. After graduation in 1915, Fuller helped form the Pinellas Boy Scouts with Katherine Bell Tippetts and received $12 weekly as St. Petersburg High School's first paid football coach. His focus from 1915 to 1918, however, was on managing his father's empire, which included the trolley system, the electric company and real estate in the Jungle area, St. Pete Beach and Pass-a-Grille. Before World War I Fuller helped plan Pinellas's first road system, a move that later benefited his real estate developments.

For two years ending in 1919, Fuller was a *St. Petersburg Times* city editor and later edited and managed Bradenton's *Manatee River Journal.* In 1919 after filing bankruptcy, the Fullers formed the Allen-Fuller Corporation with banker George C. Allen and recouped most of their former holdings. Fuller's father left in about 1923 to explore North Carolina real estate, leaving Fuller in charge of the duo's Sunshine City

holdings. As the economy burgeoned, Fuller transformed $750,000 in family assets into a $7 million boom time fortune. There was "a greedy delirium to acquire riches overnight without benefit of effort, brains or services rendered," said Fuller, who by the mid-1920s had divorced and then married journalist Eve Altsman. About 1925, Fuller advanced the Jungle area by opening the Jungle Prada and the Gangplank Night Club. The Jungle Prada, the county's first shopping center according to Fuller, "had a gas station and the trolley stopped here," said Edyth James, owner of Saffron's Caribbean Restaurant at today's Jungle Prada. The Gangplank featured a floorshow and a band that cost $6,000 monthly. The speakeasy, which closed about 1931, served its whiskey in teacups and grossed $6,000 weekly. "I, a nondrinker at the advent of Prohibition [1920], became a lawbreaker, a habitual evader of authority and a steady consumer of alcoholic beverages," Fuller told the *Times* in 1970. "The first bootlegger I ever met was me. In such an atmosphere, even the most righteous lacked the courage to speak out, and law enforcers became a lonely and ostracized group."

Filled with exotic furniture that had arrived on a tug and a couple of barges, the Jungle Country Club Hotel was the crown of Fuller's empire. After the one-hundred-room Spanish-style hotel opened in 1926, it became a palace where the rich flaunted their garish attire and spoke in multi-syllables. Some of Chicago's criminal element visited the hotel, including an associate of Al Capone, Johnny Torrio. "They were the most genteel, the best mannered guests," Fuller told the *Times* in 1972 about Torrio and his henchmen. "You'd never think that they were the kind who'd shoot you down if you crossed them." On Thanksgiving Day 1926, Fuller and R.L. Piper of Tyrone, Pennsylvania, opened the Piper-Fuller Flying Field in the Jungle area. Boasting a pair of unpaved three-hundred-foot runways and a shack with a telephone, Piper-Fuller was the city's first airstrip. Near the airport was a bootlegging operation's headquarters. On many early mornings a plane would land at the field carrying a cargo of alcohol. Before departing, the pilot would deposit a quart of whiskey on Fuller's office doorstep. Later in life, however, Fuller abstained from alcohol.

For the most part the economic boom ended in 1926, and Fuller lost his fortune. With tongue in cheek, he blamed it on the fact that the city had run out of suckers. "But it never seemed to bother him," said Billy Cooper, whose father was general superintendent of the Allen-Fuller Corp. "It kind of rolled off his back." After a decade of economic Depression, Fuller supported Franklin Delano Roosevelt's 1936 presidential campaign. A year later, he began a two-year term in

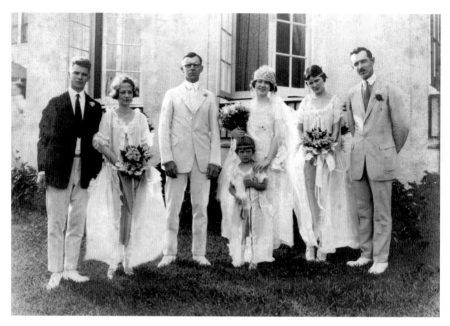

Walter P. Fuller (third from left) as he appeared at his wedding in 1923. *Courtesy St. Petersburg Museum of History.*

the Florida legislature. "He was an affable man," said Jim Robinson, a childhood neighbor to Fuller, who had once dated Robinson's mother. "He made no pretense. He was the cracker boy type. A wheeler dealer who had done everything." In the late 1930s when the Gulf Coast Highway plan lay stagnant, Representative Fuller convinced Citrus and Levy Counties to spend $250,000 on a bridge to nowhere. He then induced Florida Governor Spessard Holland to authorize the plan for U.S. 98 in Citrus and Hernando Counties and U.S. 19 in Pinellas County to meet the bridge. After an unsuccessful run for a Senate seat in 1940, Fuller became chief clerk of Florida's House of Representatives in 1943. He later wrote his memoirs, *This Was Florida's Boom*. "This is a story of the 1925 Florida land boom," Fuller wrote in that 1954 book. "The story of one of the periodic epidemics of gambling that have swept this country three or four times each century; a something-for-nothing fever with more color and substance than most; a disease born of the intoxicating tonic of Florida sunshine and sand. World War I and the recession that followed helped inflate the bubble."

Fuller took vows for the third time in his life in 1943, marrying Roberta Clarke. During the real estate boom of the 1950s, Fuller made an estimated $1 million. He lost it all by the end of the decade when

land values plummeted in 1959. From 1963 to 1971 Fuller compiled his 389-page history, *St. Petersburg and Its People*. "The doubtless numerous errors are the responsibility of the writer," said Fuller, who also taught the city's history in the course the History of Florida Cavalcade in 1967 at St. Petersburg Junior College, today St. Petersburg College. *Times* journalist Dick Bothwell wrote about the book and the course in 1972, saying, "Fuller has presented us with a family history, an album of good times and bad. [His] sense of humor and distinctive speaking style assure those attending an interesting as well as informative course."

While suffering from cancer in the early 1970s, Fuller began researching the life of developer Hamilton Disston. Fuller died in 1973 at age seventy-nine. His wife of thirty years, Roberta, and his two sons survived him. Some 250 people attended his funeral, including pioneer Jay Starkey, former mayor Robert Blanc, county historian Ralph Reed and State Supreme Court Justice Hal B. Dekle. Fuller's silver and gray casket was covered with red roses and white carnations. "Fuller had become a St. Petersburg legend long before his death," the *Times* wrote in 1973. "It is unlikely that anyone ever will do justice to the Walter Fuller story." Today, Fuller's words regarding his formula for longevity live on. "Yesterday was interesting," Fuller told the *Times* in 1971. "Today is important and tomorrow is exciting. With that formula, you can live quite a long time if you don't get run over by a truck."

Dr. Johnnie Ruth Clarke:
Grace, Intelligence and Compassion

The future is ours as we want if we claim it in the spirit of truth.
Johnnie Ruth Clarke

Driven by the malice of segregation and her disgust with the Ku Klux Klan in the 1920s, Dr. Johnnie Ruth Hall Clarke vowed to swim against a river of malevolence and become somebody. "We had to pull ourselves up by our own bootstraps," Clarke, an esteemed educator and nurse, told the *St. Petersburg Times* in 1978. "I came from rock bottom."

After experiencing an elementary education scarred by the sting of segregation, Clarke pursued high school outside the city, as did all black children whose families could afford to send them away to continue further studies. Clarke courageously set out on a journey to become one of the state's leading educators, brightening the halls of Gibbs Junior College and St. Petersburg Junior College. Clarke helped to integrate the St. Petersburg institution and was the first black to receive a doctorate from the University of Florida's college of education. "Any time you turned around, you saw the footprints she left in the educational field," said Dr. Karl M. Kuttler Jr., president of St. Petersburg College, where Clarke served as associate dean of academic affairs when the institution was St. Petersburg Junior College. Clarke fostered several medical programs and rallied behind countless health issues that affected blacks, whites and Hispanics. She served on numerous medical boards. When a new St. Petersburg health center opened in the 1980s, it was dedicated in her honor. "She had broad recognition as a great humanitarian," said resident and civil rights advocate Perkins T. Shelton. Clarke's longtime friend Chrystelle White Stewart, however, saw a different side of the compassionate educator. "One of her greatest accomplishments was as a wife and mother," Stewart said of Clarke, who hung a plaque in her office that expressed her love of people: "It is nice to be important but important to be nice."

"Blacks and whites have built this town and sustained it," Johnnie Ruth Clarke said. "That's what I like about my hometown; the people 'get it together.'" *Courtesy St. Petersburg Museum of History.*

On July 28, 1919, Clarke was born the daughter of the Soreno Hotel's head bellman and head housekeeper. As a child she would often visit Mayor Frank Fortune Pulver, who sported a white suit as he fascinated her with discussions on tourism. But it was her teachers at Davis and Jordan Elementary Schools who made the largest impression on Clarke. Instructors including Fannye Ponder and O.B. McLin instilled "the concepts of being somebody, running further than and making a contribution," Clarke told the *Evening Independent* in 1974. "There was Florence Hughes, the Perkins sisters, the Monroe sisters, the McLin girls. My translators of dreams into the reality of growing were those wonderful black women who were my teachers."

Clarke's parents, the first in their Seventh Avenue South neighborhood to have indoor plumbing, were just as insistent regarding her future. "You're going to be somebody, or I'll die trying," her mother often warned, Clarke said in a 1978 *Times* article. "Being the wise woman she was, she knew that school teaching was in our range of possibilities. It was practical to be a schoolteacher because the white society allowed you to." As most blacks in St. Petersburg were denied upper-level education in 1933, Clarke entered Florida A&M High School in Tallahassee. She received a bachelor's degree in social science from Florida A&M University and later earned her master's degree in sociology at Fisk University in Nashville. In the early 1940s, the future educator married eminent St. Petersburg dentist Dr. J.L. Clarke. The couple would have five children. Clarke taught at Bethune-Cookman College and at Florida A&M in the mid-1940s. "Her gestures and her flair made the class come alive," said Stewart, who became friends with Clarke in 1943 at Florida A&M. "She was so knowledgeable. So outgoing. She was brilliant." The friends met again in 1956, when they taught at Sixteenth Street Middle School, now rebuilt and renamed John Hopkins Middle School.

By 1959 Clarke was dean of instruction at Gibbs Junior College, now Gibbs High School, and was enjoying family and friends. "Everyone was welcome in our house," said Cathlene Clarke, the instructor's daughter, who remembered the students from Germany and Morocco who once stayed at the Clarke home. "She saw the good in everybody and had this wonderful effect on people. Her students were enthralled by her." Clarke's son Peter said, "You never put anyone down in front of her. She didn't like the 'Dr.' title outside of professional circles. She was charismatic. She'd walk in a room and everybody knew she was there. The best friend you could ever have. She cared deeply about people and the plight of African Americans." When asked, Michael Clarke trumpeted his mother the educator, who also served as Florida A&M's

personnel director and as Bethune-Cookman College's chairman of the department of social sciences. "She was a disciplinarian, the type of mom you didn't want to let down."

In 1966 at the University of Florida, Clarke became the first black woman to earn a doctorate at a Florida public university. "She was a trailblazer, a leader nationally," said Willie Felton, vice-president of educational and student services at St. Petersburg College, where a scholarship bears Clarke's name. As St. Petersburg Junior College's (SPJC) assistant dean of academic affairs in 1968, Clarke established the Total Opportunity Program, which directed high school students into employment, college or vocational-technical training. "She was always building bridges," recalled Karl Kuttler Jr., who worked with Clarke at SPJC for twelve years. Clarke, a self-confessed educational maverick, liked to create conditions in her field that would make positive things happen. In the late 1960s, the U.S. Office of Education hired Clarke as a consultant. The educator also belonged to a multitude of organizations, including the National Education and the American Educational Research Associations. "She traveled all over the country showing how to organize junior colleges," said Clarke's friend Lois Howard-Williams.

As assistant director of the Florida Regional Medical Program in 1972, Clarke established programs to battle sickle cell anemia and other diseases that affected the impoverished of all races. That same year, Clarke served as the Pinellas County campaign chairman for presidential candidate Edmund S. Muskie. The tireless instructor and humanitarian also served as a columnist in the 1970s with the *Evening Independent*. "Blacks and whites have built this town and sustained it," wrote Clarke in the *Independent* in 1974. "They will together meet the challenges the future brings. That's what I like about my hometown; the people 'get it together.'" For every person who Clarke helped educationally or medically, she felt there were multitudes more in need. "If I died tomorrow, I would be unfulfilled because I haven't helped all the people I can," Clarke said in December of 1977 in the *Independent*. Within a year, Clarke died of rheumatic heart failure at age fifty-eight. "I never realized how important she was until she died," said her son Michael. "She was always worried about not being there for us."

On May 6, 1985, at 1310 Twenty-second Avenue South, a medical clinic opened to help the poor and honor Clarke in the east wing of the Lakeview Presbyterian Church. The Johnnie Ruth Clarke Center was the beneficiary of a $200,000 federal grant and was the nation's first federally funded holistic clinic. "To be a whole person you have a physical need, an emotional need and a spiritual need," said the

center's executive director Terrye S. Bradley that opening week. "It's the spiritual aspect that makes us holistic." The Johnnie Ruth Clarke Center relocated in February 2004, moving into a 26,000-square-foot historic structure at 1344 Twenty-second Street South. At that six-acre site from 1923 to 1966, Mercy Hospital served black patients. Much of the new $4 million clinic consists of the renovated Mercy building. Clarke would have been pleased. "[My mother] rarely talked about herself," Cathlene Clarke said. "She talked about ideas. She set her own boundaries, and no one defined her. She loved life, God and her family."

Karl H. Grismer: Newspaperman, Editor and Historian

Grismer has art and skill in his pen and charm in his ink.
Writer Helen Griffith

For three decades, Karl H. Grismer traveled the states of Ohio and Florida to recount the histories of several of their cities. He researched Akron and Kent in Ohio. In Florida he chronicled Tampa, Sarasota, Fort Myers and St. Petersburg—which captured Grismer's eye so strongly that he wrote about it twice. Grismer combed through thousands of yellowed newspapers and interviewed multitudes of people to write his accounts of the Sunshine City's times gone by. From 1921 to 1928, Grismer edited the *Tourist News*. As the magazine prospered he thrived, eventually adding the title of vice-president to his editorial position. It was Grismer who lifted the glossy tourist lifeline into a popular and respected American publication. "Grismer's *Tourist News* carried St. Petersburg's message throughout the nation," historian Walter Fuller wrote in 1972 in *St. Petersburg and Its People*. "Through its existence, [it] was one of the most widely-read area publications in the country."

Born in 1895 in Akron, Ohio, Grismer graduated in 1912 from South High School. He wrote for the *Akron Evening Times* before graduating from the University of Akron in 1916. He subsequently reported for Cleveland's *Leader* and *Plain Dealer*. Grismer then worked for the *Times-Picayune* in New Orleans in 1918 and served with the Associated Press in Washington, D.C., one year later. Upon returning to Akron, Grismer became tire mogul B.F. Goodrich's assistant director of public relations. He later joined the *Beacon Journal* before coming to St. Petersburg in 1921 with his wife of one year, Delore Trew. Trew was an astute newspaperwoman who would assist Grismer on his big projects by spending hours gathering historical research. The couple would have two daughters.

To complete his 1924 *History of St. Petersburg*, Karl H. Grismer spent more than a year researching at the *St. Petersburg Times. Courtesy St. Petersburg Museum of History.*

In September 1921, Grismer became the managing editor of the *Tourist News* weekly magazine at 176 Central Avenue. Greeting him that year was a major hurricane that rocked St. Petersburg. It was Grismer's words that traveled nationwide to inform tourists that St. Petersburg was a city on the mend, basking in renewed sunshine. Grismer's stories in the slick publication ran by J. Harold Sommers were colored with skilled writing. "The early stories had been greatly exaggerated," Grismer wrote in the *Tourist News* to Northern readers about the 1921 hurricane. "Newspapers throughout the country unwittingly dealt a severe blow to Florida's West Coast by publishing distorted hurricane stories. During the height of the blast the city looked as though it were going to the bow-wows. But the St. Petersburg boosters never lost heart. Corrected reports didn't obtain much attention. They were too tame." Grismer often laced his stories with humor. "Profiteers of all classes were as prolific in Florida a year ago as fleas on the back of a mangy dog," Grismer observed in 1922 in the *Tourist News* about the economic boom in St. Petersburg. "They were encountered on every turn. Our old friend supply and demand was operating." To complete his 1924 *History of St. Petersburg*, Grismer spent more than a year researching at the *St. Petersburg Times*.

Resident A.H. Phinney helped gather historical data, providing the author with manuscripts and photographs. Grismer, who could take the most tedious statistics and weave them into a fascinating history, interviewed numerous city pioneers. He then traveled to Philadelphia to cull details about St. Petersburg's ties to the City of Brotherly Love, which included information regarding F.A. Davis and Hamilton and Jacob Disston. Grismer's St. Petersburg saga is fully illustrated, seven-and-a-half-inches long and an inch thick, bound in a dark brown cover and printed on heavy paper. Many pioneers, including the entrepreneur Davis, postmaster Roy Hanna and journalist W.L. Straub, contributed additional material and photographs to Grismer's 299-page history. In the book, Grismer discussed Pinellas's "early plant life" and "monster creatures." He covered the Spanish explorers and the pioneers before flowing into the beginning of the economic boom. Grismer's labor was unprecedented, being the first book of its kind in St. Petersburg. Historian and developer Walter P. Fuller in *St. Petersburg and Its People* called the work one of the most widely known publications in the country, "a mug book of citizens who had been great, were currently great, or had money and a yen to see their pictures" in the manuscript. Journalist Archie Dunlap noted in a 1952 *St. Petersburg Times* piece that Grismer's "work was painstaking and accurate and affords almost the only source of information regarding the early days. At one time each room in the

Detroit Hotel had a copy of that history. But they disappeared gradually as guests carried them away."

"He had a reputation of being one of the [area's] first historians," said former *Times* corporate marketing director Sandy Stiles of Grismer, who later resided at 5000 Fourth Avenue North.

After serving until 1928 with the *Tourist News*, Grismer relocated first to Kent and then Akron. The *Tourist News* was sold in 1929 and became the St. Petersburg Printing Company; three years later Grismer completed the *History of Kent, Ohio*. He worked with Akron's chamber of commerce and served as secretary to the city's mayor. Grismer rejoined the *Beacon Journal* before coming to Sarasota in 1945. That year, he told Sarasota's past in 376 pages. "Grismer has art and skill in his pen and charm in his ink," writer Helen Griffith proclaimed. "His splendid workmanship possesses that unique quality that produces highly valuable research material in addition to an engrossing story." In 1947, a thin Grismer with graying hair and luminous eyes appeared in St. Petersburg to again put the city's past to the page. The Sunshine City's population had increased from 14,237 in the 1920s to more than 100,000 in 1945. Most readers found the *Story of St. Petersburg* an improved version of his initial work in 1924. In his friendly and accurate style, Grismer blended his verbiage with the newer events of the 1930s and the 1940s to create a masterful history. According to *Evening Independent* journalist Paul Davis, prominent residents paid money to appear in the book's biographical section.

"Grismer was very choosey about whom he admitted to biographical space in his books," wrote Davis, who helped the historian pick nearly one hundred biographies to appear in the second narrative. In a 1948 issue of the *Evening Independent*, Grismer explained his love for research. "You get involved in a history. Your curiosity about what happened in certain situations of growth and progress become intrigue, and you hurry to see how things turnout." Grismer tackled the history of Fort Myers in 1948, leaving gracious residents to call it a civic asset. "In its pages may be found the flavor of the past, the inventory of the present, and by many implications the course for the future," the *Fort Myers News-Press* wrote that year. In 1950, Grismer compiled the city of Tampa's first history. The 431-page manuscript captured the arrival of the city's first family, Mr. and Mrs. Levi Collier and their five children. In early pages of the Tampa account, Grismer focused on Henry Plant's empire and illustrated how the railroad magnate ignited a Tampa revival. Later in the book, Grismer documented the city's experiences during both World Wars. Lung surgery in Miami interrupted Grismer's work on the *History of Akron and Summit County*—which he was calling a monumental

work that he had initiated to honor his thirty-some years of writing city histories. After the surgery Grismer returned to his Sarasota home, where he died at 8:00 a.m. on March 13, 1952. He was fifty-six. "It is a pity that Karl Grismer could not have lived long enough to enjoy the praise which will be justly his when his *History of Akron and Summit County* is published," read a section later devoted to Grismer in the Akron book. "His reward will come in the respect which Akronites and future generations will have for the careful research and sprightly writing which goes into the history of the city and county." After Grismer's death, Mrs. Grismer worked with great speed to complete the book. About a month after its printing began, she died of a stroke.

"This dedicated couple, who spent years searching old newspaper files to ensure accuracy, did not live to see their final work," the *Independent* wrote in 1968. "The eight hundred and thirty-four page book...won wide acclaim."

Dr. Ernest A. Ponder:
A Struggle for Excellence

Ponder put sixty minutes worth of work into every minute. The students had a deep respect for him.
 Emanuel Stewart, former Gibbs High School principal

When more than two hundred admirers gathered to honor educator Ernest A. Ponder at a luncheon in October 1994, it was fitting to call it "A Celebration of Love." Ponder was so moved at the event that a flood of emotion suspended his speech. "When he got up to talk, he started crying," said his wife of fifty-six years, Clara Ponder. "He had to sit down and continue later."

From 1945 to 1969, Ponder battled segregation's fallout as a Gibbs High School instructor. He headed Gibbs's social studies department and reestablished its choir before teaching at Lakewood High School. After his retirement in 1979, he wrote and lectured on local black history. "Ernest made a tangible contribution to society and the world because of his talents and drive," said Ella Mary Holmes, who befriended Ponder while both were Davis Elementary School students. "He was a thorough, resourceful educator who encouraged his students to pursue higher education." Clara Ponder said that she'll "always see him in the classroom teaching. They wanted to make him a principal, but he refused because he wanted to teach."

On April 3, 1918, Ernest Ayer Ponder was born in New York City. He came to St. Petersburg at age six from Ocala in 1924 with his parents, James Maxie Ponder and his legally adoptive mother Fannye Ponder. Ponder's father became the city's first black physician; his mother taught at the all-black Davis Academy and later emerged as one of the city's esteemed educators and health advocates. After settling in Methodist Town, a middle-class black section of St. Petersburg, Ponder began his education at Davis Academy and later attended Gibbs High School. "Ernest was an energetic, curious

"If I saw a spark of potential in a student, I got right on it and stayed with it until something materialized," Earnest A. Ponder said. *Courtesy Clara Ponder.*

child, an achiever," said his sister Alyce Bennett. When the Depression provisionally closed St. Petersburg's black schools in 1932, Ponder attended a model high school at Bethune-Cookman College in Daytona Beach. He studied two additional years at the college after finishing his high school education. He toured with the college choir and served as a chauffeur for Mrs. Bethune, a close friend of his mother's. Ponder later graduated from Morehouse College in Atlanta and then studied at the New York School of Embalming. He married Clara Meshaw in 1942; the couple would have one

daughter, Erna Claire. During World War II, Ponder worked for the War Department at the adjutant general's office in Washington, D.C.

To satisfy his family's needs in 1945, Ponder returned to St. Petersburg and assumed his mother's position as social studies teacher at Gibbs High School. He was paid ninety dollars a month. "Back then, blacks took jobs as teachers because there was nothing else—unless you were a doctor or a lawyer," Ponder told the *St. Petersburg Times* in 1998. "I taught in the same room [my mother] taught in." For twenty-five years, Ponder convinced Gibbs students that they needed an education. He helped them financially by providing lunch money, supply costs and bus fares when Pinellas County failed to provide such necessities to black students. He clothed and counseled students and provided musical instruments for the talented but destitute. "He encouraged us to learn despite the conditions that surrounded us," former student and author Rosalee Peck said. "He was a caring teacher, the no-nonsense kind." Emanuel Stewart, former Gibbs principal from 1958 to 1970, said Ponder "put sixty minutes worth of work into every minute. He had the advantage of growing up under fine parents, and he wanted to share that with his students to raise their intelligence. The students had a deep respect for him. An ideal person. An excellent role model. I would have loved to have him as a brother or a son."

In the late 1940s, Ponder—who had a beautiful tenor voice but no music degree—reestablished Gibbs's St. Cecelia Choir. "When they sang at white churches, they were told to enter the back door," Clara Ponder said of the choir that performed throughout Florida. "Ernest had them walk down the center aisle with heads held high." Sometimes Ponder's choir was told not to show up, however, like the day in the 1950s when a white church official called to cancel an event because it might be problematic. "It bothered all of us," Ponder told the *Times* in 1989. "But what could we do. The movement to integrate did not come until later. I think the attitude [the students] took was, 'that figures.'" Whether Ponder was directing the choir or teaching social studies, his students came first. "If I saw a spark of potential in a student, I got right on it and stayed with it until something materialized," Ponder said to the *Times* in 1981. Clara Ponder said her husband had a knack for communicating with teens. "How many of you would like a nice marriage with a nice husband?" Ponder once asked his pupils, according to notes from a Ponder lecture now preserved in this author's files at the St. Petersburg Museum of History. "How many of you would one day like a nice little home? If you get pregnant in the next two or three years, you can forget it. School is still the gateway to many valuable rewards."

In 1969 during the rocky days of integration, Ponder began teaching at Lakewood High School. "I don't think he had any problems," Clara

Ponder said. "The kids took to him." After his retirement in 1979, Ponder served with the Area Agency on Aging and the Silver Haired Legislative Delegation. He wrote and lectured on black society's contribution to the city. "The history of the black community in St. Petersburg is like the glimmer of a darting snowflake, seen clearly only for a short while and quickly flickers away," Ponder wrote in the same lecture notes referenced earlier that are preserved at the museum. "Thus a search for [black] history results in a configuration of pieces here and there." In 1986, Florida Governor Bob Graham appointed Ponder to the Distinguished Black Floridians Council. Three years later Ponder rebuffed school integration and proposed open enrollment or school choice, a system allowing parents to choose a school for their children. "There is something artificial about school integration," Ponder told the *Times* in 1989. "It gives us the notion that we are in, but we are still out. I knew a time when kids were optimistic. They didn't feel this sense of hopelessness. I see kids now looking angry at the world. I'm disappointed in terms of overall gains. With the exception of athletics I just haven't seen any positive results. Kids don't speak any better; fewer are going to college, and the dropout rate is ridiculous." (Seventeen years later in August of 2003, Pinellas County schools adopted school choice.)

In a 1994 declaration, Florida Governor Lawton Chiles proclaimed October 15 as Ernest Ayer Ponder Day. More than two hundred Ponder devotees gathered the next day at the St. Petersburg Howard Johnson in "A Celebration of Love." Red ribbons with gold lettering echoed the group's sentiments: "Because Of You, We Are." One graduate thanked Ponder for giving her daughter a violin for music class. Former pupil Dr. Kha Dennard, one of the event's organizers and a member of the seventy-strong Friends of Ernest Ponder, said, "Mr. Ponder has spent more than 40 years earning his 15 minutes of fame." Ponder's former student Rosalee Peck also spoke at the event: "I remember once when we, the students, were complaining about using old books sent to Gibbs from white schools that a lot of the pages were torn or missing. Mr. Ponder said calmly, 'Okay, we'll just read from the pages that are left.' He taught us survival skills." After the festivity, Ponder's wife said the gathering was a celebration requiring months of preparation: "We started planning the event in April. I never said a word to him about it."

On January 18, 1998, Ponder died at home of heart failure at age seventy-nine. "You can't imagine the shock I felt when I was called by Mrs. Ponder," childhood friend Ella Mary Holmes said. "I raced over to his Lakewood Estates home. Ernest and I were friends to the end. He was tall, handsome and very proud. He always wanted to be young and was quite the perfectionist. I still miss my old friend."

Dr. N. Worth Gable Jr.:
Physician and Warrior

Gable was one doctor who had an imposing medical and military career.

<div align="right">Retired journalist Mary Evertz</div>

While organizing and training the city's first local National Guard ambulance unit in 1936, Dr. N.W. Gable Jr. imparted spirit and style to his unit. "The men were issued dashing uniforms, rakish caps and shiny boots, and won any number of drills," Gable told the *Evening Independent* in 1965. "We had two ambulances [World War I surplus with frail tires], a truck, and a motorcycle with a sidecar. But they'd never give us the prizes."

From battling Mexican revolutionary Francisco "Poncho" Villa to advising the Chinese army, Gable earned numerous American and foreign honors during his four-decade military career. At home he organized St. Petersburg's first civil defense outfit. After establishing the city's first armory, subsequent armories have carried the Gable name here since 1942. Gable came from a family of doctors and excelled as an area physician for nearly half a century. After founding and presiding over the Pinellas County Medical Society, he served as chief of staff at three area hospitals. "He was among the top ten doctors in town during the mid-1930s," said former guardsman and resident Charles Louie Crawford. Master Sergeant Mark Warren wrote of the physician and warrior in an undated press release preserved in the archival files of the *St. Petersburg Times*: "The history of Colonel Gable is long and interesting."

In 1899, Nonie Worth Gable was born in Brooks, Georgia. He joined the Georgia National Guard hospital corps on April 24, 1916, as part of the Fifth Infantry. After the Georgia National Guard was federalized in June of 1916, Gable was called to arms on the Mexican border to battle Villa's forces. Gable then taught military instruction at Holy Cross College

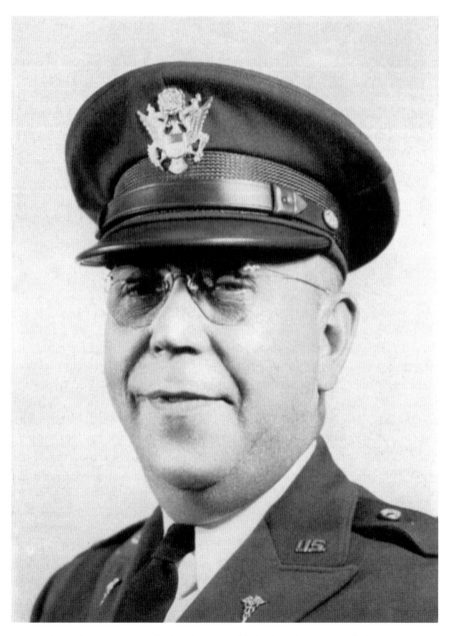

In April 1936, Dr. N. Worth Gable Jr. established and commanded St. Petersburg's first National Guard unit: the 118th Ambulance Company. *Courtesy St. Petersburg Museum of History.*

in Worcester, Massachusetts, in 1918 as a second lieutenant. After World War I, he became a first lieutenant in the army's officer's medical reserve. Gable graduated in 1923 from Emory University in Atlanta as an eye, ear, nose and throat specialist. He later completed postgraduate work at the University of Vienna, Austria; Kings College of London; and the Eye and Ear Infirmary in Manhattan. In 1925, Gable established his St. Petersburg practice and four years later married Ethel Rockefeller. The couple had one son, Roderick, and resided at 2345 Trelain Drive. By 1931, Gable had received a military commission as a captain. As the clouds of war hovered over Europe in April 1936, Gable established and commanded St. Petersburg's first National Guard unit—the 118th Ambulance Company. "We trained at Camp Foster [Jacksonville] and Fort Bragg [North Carolina]," said Jack Rankin before passing away in 2004. "Fished, played craps and poker. We had one helluva good time."

After attending chemical warfare school in Maryland in 1938, Gable returned to his unit as a major. Two years later the group became the 116th Field Artillery, 31st Infantry Division. Gable's division included First Sergeant Henry Hill, who was called "the best damn top kick" ever during the unit's twenty-fifth anniversary gathering in 1965 at St. Petersburg's Sand Dollar Restaurant, reported the *Independent* in 1965. Drill Sergeant Frank Clauss was described that day as "still peppery," a man "who could even march his men around the concrete pillars" at the Fourth Street North's Coca-Cola Building, now Sunken Gardens. Pop Phoenix was labeled "a master sergeant without peer," and Supply Sergeant Howard Emory was acknowledged as the one who made the men "the best dressed unit." On October 5, 1940, Gable was installed as the president of the Pinellas County Medical Society, which he had earlier helped found. "Dr. Gable was a natural good guy and gentleman," said Sidney Hilliard, a guardsman who served under Gable and was a patient of the physician. "He was a very thorough doctor." On March 24, 1942, a new $70,000 armory on Sixteenth Street North at Woodlawn Park was dedicated in Gable's name. Luminaries included Governor Spessard Lindsey Holland and Brigadier General Vivian Collins. "This proves a proud day in the city's history—and a happy one," a 1942 *Times* editorial read. "Major Gable worked indefatigably to put through this project. His enthusiastic interest in the National Guard contributed importantly not only to actual erection of the building but to the organization of military units in the city which today are an active part of the nation's armed forces."

As part of the army's medical branch in 1943, Gable was sent to China sans his unit as a surgeon and military advisor for the Southern

Command of the Chinese Combat Command. There he assisted Chinese troops in the numerous techniques of modern warfare and developed the battle readiness of the Chinese field armies. The Chinese army awarded him the Medal of Merit and the Grand Star of Honor. During his five-year tour that also included Burma and India, Gable was elevated to major general and received the Bronze Star. "A much decorated soldier," Master Sergeant Mark Warren said of Gable in that *Times* undated press release written after the war, when Gable was training his own son among other recruits at Fort Jackson, South Carolina. In 1948, Gable was awarded the Florida Cross for his distinguished military service. His citation acknowledged his "attention to duty, continuous superior discharge of all assignments and progressive leadership," according to a *Times* 1971 article. On the local medical scene with *Times* editor Stan Witwer in 1951, Gable established the *Times*'s Medical Forum, a monthly gathering during which residents posed questions to doctors. "I believe they met at Christ Methodist Church," said former *Times* journalist Mary Evertz. "It went on for several years. It was an opportunity for the public to have contact with area doctors. And Gable was one doctor who had an imposing medical and military career." The *Times* wrote in 1971 that the forum concept was later adopted throughout the nation and worldwide.

When Gable retired as a brigadier general in 1957, the Guard honored him with a ceremony and review at Tampa's Fort Hesterly Armory. At 4:00 p.m. on March 1, 1959, under sheets of rain in St. Petersburg, a new $213,080 armory was dedicated. About 120 civilians witnessed the ceremony at 3601 Thirty-eighth Avenue South that consisted of an open house, refreshments and speeches. "It's the responsibility of government not only to furnish buildings for the military, but to keep them filled with manpower," said Major General Mark W. Lance, then adjutant general of the Army National Guard. "While we dedicate this armory, let us also rededicate ourselves to fulfilling our obligations to our country with active support for our government." Some 500 guests danced at the evening ball until 1:00 a.m., according to a 1959 *Independent* article. Months later in 1959, the armory was named in Gable's honor. This is "a mark of honor and in recognition of the distinguished military service" rendered to the State and National Guard by Gable, read the order of then Governor LeRoy Collins published in a 1959 *Independent* piece. The former armory on Sixteenth Street North was later purchased by the city for recreational purposes. For the next twelve years, Gable belonged to every local medical association and numerous civic groups including the Masons, Shriners and Chamber of Commerce. At various times he was

the chief of staff of the city's St. Anthony's, Mound Park and Mercy Hospitals. On June 28, 1971, just months after closing his practice, Gable died after a long illness. He was seventy-two.

"Many will feel a distinct loss," the *Times* wrote then. "The Gable name has been associated with medicine even longer than a half-century. The father, Dr. Nonie W. Gable Sr...was St. Petersburg's city physician before his death in 1954. [Sr.'s] first son, Dr. Linwood M. Gable, who died April 10, 1970, practiced here for many years. And [Sr.'s] third son, Hulette R. 'Booney' Gable is owner of the Gable Clinical Laboratory."

Margaret Acheson Stuart:
The Heart of St. Petersburg's Art

[Stuart] *insisted on everything being top quality.*
Bethia Caffery, former *Evening Independent* reporter

Margaret Acheson Stuart loved art. Her tastes were expansive, ranging from Renoir to Rembrandt, from Manet to Monet. She cherished traveling to American and European cities, but only if the visits included extended stops at art galleries. "I've gone to museums between trains," a 1961 *St. Petersburg Times* article quoted Stuart, an alert quick-moving woman with dark green eyes. "I've even kept a taxi waiting when I had to catch a train, while I ran into the National Gallery to have one more look at a certain painting I liked. I don't mean that museums are an obsession with me. It's hard to put into words."

About 1959, Stuart returned to St. Petersburg and saw a city without a museum. To her the area was lost sans a museum. In response, she presented St. Petersburg with more than $1 million; a fine arts museum was the result. The St. Petersburg Junior Chamber of Commerce then made Stuart the first woman to receive its Outstanding Citizen Award. For the next fifteen years, Stuart was the heart of the museum. "Our St. Petersburg Museum of Fine Arts would not exist (or perhaps ever) were it not for the courage and munificence of Margaret Acheson Stuart, who conceived the idea of an art museum for St. Petersburg," local historian Walter P. Fuller wrote in 1972 in *St. Petersburg and Its People*. In 1895, Stuart was born in Monongahela, Pennsylvania. She was the seventh of nine children born to Edward Goodrich Acheson who, backed by Andrew Mellon, founded the Acheson Graphite and Carborundum Corporation. It was Edward Acheson's work with tungsten that enabled his friend Thomas Alva Edison to invent incandescent light, according to a history compiled by the Museum of Fine Arts. After her father had relocated the family to New York, Stuart found a second home

As a young lady, Margaret Acheson Stuart visited numerous museums. *Courtesy St. Petersburg Museum of Fine Arts.*

at the Metropolitan Museum. "I remember going to the Metropolitan Museum and seeing a Rembrandt painting," Stuart told the *Times* in 1965. "After the visit, the beauty of the painting remained so vividly in my mind that I had to return to see it. So I went back, and then started stopping in every day."

After attending boarding schools in New York and London, Stuart graduated at age eighteen from Mount Vernon Seminary. She then studied bookbinding, interior design and took a two-year secretarial course in New York. To overcome her shyness, Stuart became an acting student while in her twenties at New York's American Academy of Dramatic Art. She appeared on Broadway and was once actor Lynn Fontaine's understudy. Stuart—who liked a glass of Dubonnet before dinner—enjoyed acting, but she never achieved her goal. "My theory was all wrong, a course in dramatic art doesn't cure a person of shyness," she told the *Times* in 1961. "I played my parts well but I was only speaking the playwright's words. When I wasn't playing a role, I was shy Margaret Acheson again." By 1926, Stuart's family had adopted St. Petersburg as a winter residence. She married contractor Lyall Stuart five years later. For the next several decades, Stuart pursued her love of art as the couple visited museums in Sweden, Norway, Denmark, Holland, Italy and France. After divorcing in the mid-1950s, Stuart settled here about 1959. "I love St. Petersburg," she told the *Times* in 1965. "I decided to settle here permanently, rather than just coming down a month every year. However, I thought, how can I? There is no museum. I could not stand the thought of living in a city without an art museum."

After weighing the possibilities, Stuart embarked on a mission to establish a museum here. "Beneath that quiet ladylike quality lurked a Don Quixote determination that whatever she thought was right, was right, and whatever she wanted to be done, would be done," wrote Peter Sherman in his memoirs of his friend Stuart. Sherman's memoirs are now preserved in the archives of the St. Petersburg Museum of History, in this author's files. Stuart, who later in life raced through her days sporting dresses crafted in an A-line style, established a $1 million museum trust fund and donated $150,000 for construction costs. She pledged $10,000 annually for design. Everything was for the people, Stuart said after refusing to place her name on the museum or charge admission. She then spent several months studying museums. "I went to New York and to the Metropolitan Museum library to copy down their charter," Stuart—who covered her eyes when approaching nude figures of art—told the *Times* in 1966. "I also went to the American Federation of Arts for their help." On May 4, 1961, the city council resolved to

In the 1960s, Stuart forged her plans for a fine arts museum in St. Petersburg. "I could not stand the thought of living in a city without an art museum," she said. *Courtesy St. Petersburg Museum of Fine Arts.*

approve Stuart's dream. "WHEREAS, this Council has accepted this offer with the realization that the establishment of this Museum will be one of the most outstanding forward steps made in the Cultural development of the city of St. Petersburg. NOW, THEREFORE BE IT RESOLVED by the city council of the city of St. Petersburg, Florida, that on behalf of the citizens of this city we extend to Mrs. Margaret Acheson Stuart our sincere thanks and appreciation for this most generous contribution to our civic development."

On June 29, 1961, the city signed over Stuart's handpicked site at 225 Beach Drive Northeast to the museum group for $10. Within a year after the resolution, volunteers had organized the Margaret Acheson Stuart Society to assist in many of the costly and necessary needs involving the museum's pre-planning. By August 1963, architect John L. Volk and Associates had incorporated Stuart's concept into plans and A.P. Hennessy and Sons had begun construction. "I remember walking around the foundation," said Fay Mackey Nielsen, Stuart's great-niece, who loved a different Stuart than the shy, proper figure the public knew. "She was always animated with the family, excited about things, just whatever you were interested in," Nielsen said of Stuart, who drove a Corvair despite Ralph Nader's warnings and enjoyed reading author A.A. Milne's *Winnie the Pooh* cross-legged on the floor. "She had a lot of joy." On February 6, 1965, between two and three thousand guests attended the inaugural preview of the $850,000 facility. At the time of that unveiling there were more than twenty-five hundred charter members to Stuart's home of art, the Florida west coast's first free general museum. More than seventy art lenders, including the Boston and New York museums and the Smithsonian Institution, elevated the exhibition's value to $3 million. Museum highlights included nine galleries, an art reference library and a membership garden in an enclosed courtyard. "[Stuart] insisted on everything being top quality," said Bethia Caffery, former *Independent* reporter. "The building. The opening inventory." Despite a brief electrical failure, some ten thousand people and one escorted dog attended the February 7 public opening. "Margaret Stuart looked radiant," Sherman said. "How she turned away the compliments…with words of praise for the volunteers, the staff." Nielson said that Stuart—who lived on Redington Beach and later at Brightwater Towers—"was lit up, just kind of glowed [during the opening]. She was walking on air."

As museum president, Stuart kept the establishment in the forefront and remained in the background. "Many a museum visitor has probably noticed a slight figure with snow-white hair slipping quietly through the

galleries and never known that this is the woman who made possible his visit and the treasure house he is in," the *Times* wrote in 1966. Margarita Laughlin, a former museum registrar, said Stuart "was very discreet about her life and there was a refinement, a class to her." Rexford Stead, the museum's first director, looked upon Stuart with awe. "Do you know any other museum president who comes to the building practically every day?" Stead was quoted as saying in Sherman's memoirs. "Who binds and repairs books and periodicals…teaches bookbinding, polishes silver, does needlepoint embroidery, helps with displays and often makes tea for fellow workers?" Between 1972 and 1973, Stuart contributed $300,000 for the museum's Sculpture Garden and the Marly Room additions. In 1978 she received the Florida Governor's Award for the Arts. "It was as if you were in royal presence," Sherman said about being with Stuart. "She didn't demand it. She just was it." After visiting New York's American Wing of the Metropolitan Museum of Art in 1980, Stuart lapsed into a coma. She died several weeks later on July 10, in St. Luke's Roosevelt Hospital at age eighty-five. As Stuart had wished, her ashes were buried without a marker in the St. Petersburg Museum of Fine Arts's Sculpture Garden.

"If one child has a better life because he visits our museum," Stuart had told the *Times* in 1961 in her quiet, cultured voice, "then the whole thing will be worthwhile."

The Florida Theatre:
St. Petersburg's Palace

It was like being in a Spanish castle. It was a dark cave with the smell of popcorn permeating the air.

Resident John Schuh

When the wrecking ball declared war on the Florida Theatre in 1968, numerous residents gathered to witness their old friend die. With long faces they filled nearby sidewalks, their eyes open and their mouths closed. As the machinery tore gaping holes in the ornate structure, one old-timer expressed his grief. "Sorry to see the building go," the *Evening Independent* reported him saying. "Enjoyed lots of entertainment there." Then his eyes brightened. "Say, you remember those Bank Nights of the Depression years? Lots of excitement they caused every Friday night, crowds in the street waiting for the lucky number to be called out. Everyone keeping their finger crossed for good luck."

That January in 1968, progress growled at the Florida. For forty-one years it had befriended residents, whisking them away from their mundane worlds and adding joy to their souls. Such eclectic diversions as vaudeville, films, concerts and those Bank Nights brightened the Florida, the city's first air-conditioned building and once the state's largest theatre. "Sitting in the theatre, awash in blue lights, you'd hear the rumble of an Atlantic Coast Line train," city native John Schuh said. "It was like being in a Spanish castle. It was a dark cave with the smell of popcorn permeating the air." Said resident John Ormsby about the twenty-five hundred seat Florida at First Avenue South and Fifth Street: "It looked like an old opera theater. Very large restrooms. A huge balcony. I remember seeing *Old Yeller* there and visiting the projection booth."

On February 26, 1926, the president of the Publix Theater Corporation, Aubrey Mittenthall, told the Sunshine City why it was chosen to house the Florida. "St. Petersburg was the logical location for

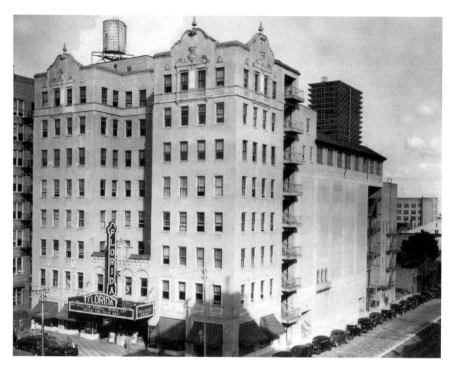

"St. Petersburg was the logical location for the erection of the first theater of the circuit," said Aubrey Mittenthall, president of the Publix Theater Corporation. *Courtesy St. Petersburg Museum of History.*

the establishment of our executive headquarters and the erection of the first theater of the circuit. The offices of the corporation consider St. Petersburg a real live show town." In 1926 when the construction of the Florida had locals gushing with excitement, Ashford Greeley was there. "I watched every brick go up," the *St. Petersburg Times* in 1958 quoted the former Florida stage manager, who served the theatre from its inception until its demise. "I sure was tickled when I got the job." Several months later on September 10, 1926, a line formed nearly five hours before the Florida's 7:45 p.m. grand opening. Boys profited by standing in line for impatient men; anxiety ran high. By show time the Florida filled with a capacity crowd of 2,500, the largest crowd to witness a local theatrical performance. As the St. Petersburg Orange Band played, patrons shivered under the brisk blow of air conditioning. The national anthem drew applause, followed by Senator William Hodge's speech. "I am opposed to censoring pictures," Hodge said, reported the *Independent* at the time. "The Lord never intended that men and women should live in an atmosphere of the bowed head and the downcast eye. In the name of

Governor Martin, I dedicate this sunshine theater in this Sunshine City to the entertainment, the education and the inspiration of the people."

After Mayor R.S. Pearce expressed the city's gratitude, dancers frolicked to organ music. When *Tin Gods* starring Thomas Meighan and Renee Adoree appeared on a screen twenty feet wide and eleven feet high, Hollywood came to St. Petersburg. "A comedy closed the program, and the crowd left the theater…feeling that it had had a part in a notable event for St. Petersburg, marking another step forward in its progress," the *Independent* wrote then. Greeley would come to love the art that graced the $1million structure. Multitudes of times he traveled the sweeping staircases that led to five balconies; he treasured the theatre's tapestry, Occidental architecture and ornate beamed ceilings. Nearly two thousand light bulbs and numerous crystal chandeliers left Greeley awestruck as they brightened the Florida's majesty. Oil paintings of Spanish galleons and ominous nobleman captivated him. Grand mirrors and Spanish armor enveloped him. Later in 1972, the *Times* would call the Florida "the largest and most ornate theater south of Atlanta. [It had] gilt rococo chairs, red velvet-covered benches and lamps of wrought iron. An orchestra pit that could be raised and lowered. A balcony and a three-story pipe organ."

During the Depression from 1934 to 1938, when theatre tickets were about thirty cents, Bank Nights ruled. Residents flooded the Florida every Friday night to claim a number. A winner was later selected from a huge barrel. "I'd holler out the name as loud as I could," the *Independent* wrote in 1967, quoting Walter B. Tremor, then city manager for Florida State Theatres. "Sometimes it seemed like there were more than 1,000 people out there." The biggest winnings ever totaled $1,050. Eventually reformers and better economic times ended Bank Nights.

On most weekends atop the Florida's tile roof at the Pigeon Roost, guests danced under a canopy to the beat of Rex MacDonald's Silver Kings band. Elevators and rain, however, ultimately halted any dancing and romance amid the garden atmosphere. "You couldn't get people to ride an elevator in those days," the *Times* wrote in 1967, "much less go to the roof of a building."

Through the years, stars including Elvis Presley and George Jessel appeared onstage at the Florida. Exotic dancer Sally Rand entertained many patrons at the popular theatre, especially when a boy took aim with a BB gun and popped the bubbles covering the star. In 1957 the Florida presented the play *South Pacific*, its last live production. "I can still see the stage," resident Lloyd Branch said. "The opulence. The marvelous architecture. You just don't see such things." Ten years later on a screen

twice the size of the original—forty feet wide and twenty-two feet high—Clint Eastwood's *For a Few Dollars More* ended the Florida's reign. Nearly fifty viewers savored the saga, enhanced by three sets of speakers behind the curtain and twenty-two more throughout the auditorium. "On the screen, bodies fell like cordwood, 27 in all," journalist Dick Bothwell wrote in the *Times* in 1967. "The lights came on as a wagonload of corpses departed. There were a few scattered handclaps. A tombstone flashed upon the screen—"RIP Florida 1926–1967." In the lobby, candy machines clanked as they were emptied."

On October 1, 1967, First National Bank purchased the white stucco Florida for $225,000. The structure had suffered through a hurricane and the stock market crash and had entertained the city with vaudeville, silent pictures and talkies. Studies reflected that about $100,000 was needed just to redecorate and clean up the theater. "To completely modernize the building would have cost more than half a million dollars," bank president Harmon Wheeler told the *Times* in 1967. "That would not be feasible, because we would just end up with a modernized 41-year-old building." Exactly a week and forty-one years after the Florida's opening, about 135 of its effects were auctioned off. Carved chests, wrought-iron lamps and mirrors dating back to 1838 drew some 400 souvenir hunters that April in 1967. Patrons gathered an hour and a half before the 8:00 p.m. auction. Before the event, auctioneer P. Frank Stuart declared that an item would be sold every minute—cash or check welcome. James W. Brown Jr. paid $10 for the first souvenir: a Leonardo da Vinci print, *Beatrice Estes*. A microphone projected Stuart's calls, and he often strained to hear the bids. For the last time, the smell of popcorn permeated the Florida.

When the six thousand-pound steel wrecking ball came in 1968, the Florida fought back. Two workers were nearly killed when an eighty-foot crane crashed to the ground during the attack. "For several weeks now, downtown St. Petersburg has been the scene of a symbolic battle—the old Florida Theatre Building vs. the great metal fist of the Cuyahoga Wrecking Co.," the *Times* wrote in 1968. "[The Florida] was so solid the wrecker lost many attempts to remove it, because it was so well built and in such fine condition. The building is like a tough rugged soldier of Spartan mold, fighting grimly to the very last." Writer Ted White bemoaned the devastation. "The loss of the Florida was a terrible waste. The Florida had great potential to become a true center for civic functions. Had there been adequate community action and even a minimum sense of basic responsibility, it would be standing today."

Gibbs High School:
The Miracle on Thirty-fourth Street

There was a strong eagerness to learn, a sense of loyalty to the school…
an indomitable spirit.

Former Gibbs Principal Emanuel Stewart

When Gibbs High School celebrated its fiftieth anniversary in 1979, a multitude of former and current students bonded while sharing memories of such Gibbs educators as O.B. McLin and Ruby Wysinger. Principal Emanuel Stewart addressed that crowd and spoke of marvels. "New students will feel privileged when they are chosen to attend this Miracle on Thirty-Fourth Street," Stewart said, according to a school history of the event. "In spite of the inadequate facilities of [our] yesteryears, there came from these halls students who achieved to their fullest potential."

For decades after opening in 1928 as a high school, Gibbs endured systematic neglect from the Pinellas County School Board. Daily its black students endured inadequate facilities and shared secondhand supplies. Enrollment at times doubled its capacity. Integration placed new challenges on the institution as it labored to maintain its identity. "How did anything worthwhile come out of the old Gibbs?" Stewart added during the celebration before praising McLin, Wysinger and Dr. Ernest A. Ponder. "There was a strong eagerness to learn, a sense of loyalty to the school…an indomitable spirit."

Prior to 1928, Pinellas County offered education past the sixth grade only to white students. Only economically privileged black families could respond by enrolling their children in private, church-related or prep schools on black college campuses. Later in 1927, school officials anticipating westward expansion began construction of an eight-room, $49,490 elementary facility for whites at Ninth Avenue and Fargo Street. The Depression, however, crippled white expansion westward. In a move

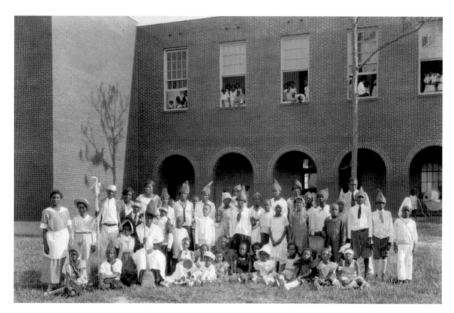

In 1935, Gibbs High School students pose during a school pageant. *Courtesy St. Petersburg Museum of History.*

that made use of the structure and perpetuated segregation, the building became the Thirty-fourth Street Colored School. Its first graduating class in 1928 numbered six students.

"We later sacrificed our avenues for the school," said former Gibbs student Minson Rubin, who created an exhibit honoring Gibbs in 2005 at the St. Petersburg Museum of History. "There is no Fargo Street today. No Ninth Avenue South."

About 1928, the students and faculty named the school after black clergyman Jonathan C. Gibbs. The native Floridian Gibbs was born in 1827. At about age forty-one in 1868 he was elected to the Florida Constitutional Convention. Gibbs served that year as Florida Governor Harrison Reed's secretary of state. Ten years later, he held the position of state superintendent of public instruction. Gibbs died mysteriously in 1874 amid rumors he was poisoned. In the school's early days, a custodial room served as Principal Samuel Reed's office. Its library consisted of books received from churches and organizations. Desks and textbooks were castoffs from St. Petersburg High School and other white institutions. "We had carved up desks," said Ella Mary Holmes, a former Gibbs valedictorian (1934) and Pinellas County educator. "Families had to buy textbooks before the county sent discarded ones. It was amazing how dedicated the teachers were. We had no real library but the teachers and parents were gung-ho."

That is all you hear about the dedication of the black teachers

— Inroads by blacks politically before Compromise of 1877

During those thorny days, Gibbs teachers shared good rapport with parents, ministers and community leaders. Instructors inspired their students to excel under their direction, despite the neglect from the school board that they experienced. Dr. Ponder once called the Gibbs teachers "purveyors of culture." He said McLin made her students read classics scribed by literary greats including Chaucer and Shakespeare. "Teachers such as Olive B. McLin, Ernest A. Ponder, Ruby Wysinger, Lena Brown, Corrine Young, Eloise Perkins and T.C. Stockton were determined to prevent Gibbs from being hampered by the school's inadequate facilities," the Pinellas County School Board wrote in its 1987 book, *A Tradition of Excellence.*

While principal from 1929 to 1932, George W. Perkins established a program that sold bricks for ten dollars each to build a gymnasium and auditorium. In 1932, McLin established the acclaimed St. Cecelia Choir. The choir "often sang to standing-room-only audiences whether it was touring the West Indies or the Washington, D.C., area," the *St. Petersburg Times* reported in 1980. Theresa McKinney succeeded Perkins in 1932, becoming the county's first female high school principal. The Reverend John Carter and Noah W. Griffith then served as principals, followed by the return of Perkins (1938–46). Under Perkins, the Gibbs Library and Perkins Elementary School were established.

At this time teachers' pay was also an issue, as black instructors were routinely underpaid. "They actually paid black teachers less than white teachers," Holmes said. In 1938, Superintendent Greene V. Fugguitt fired five black teachers when Griffith unsuccessfully took the matter of insufficient salaries to state court. Meanwhile, evidence surfaced in a 1943 city report that overworked Gibbs educators were instructing 781 students in a school built for 350. It wasn't until October 17, 1945, that the Pinellas County School Board balanced the pay scale for white and black teachers.

Despite having to travel as far as Jacksonville to engage other black schools in sports, Gibbs often fielded winning teams and the graceful moves of their marching band were celebrated. White schools reportedly copied the chants of the Gibbs cheerleaders nationwide. When they traveled, the Gibbs Gladiators stayed in opponents' homes. All home football games were played in the "Dust Bowl," bleacher-less Campbell Park. "All our suits and equipment were secondhand," former student Al Davis told the *Times* in 1978. "The only sports we played during that time were football and basketball. We really didn't get a sports program until Joe Johnson got here [in 1947]." In 1956, the Gibbs footballers were crowned state champions. Within a decade, the school had become the first black school in the Southeast to earn admission into the Southern Association of Colleges and Schools.

The Gibbs Balladiers and instructor Ernest Ponder gathered together on the school's steps in 1948. *Courtesy St. Petersburg Museum of History.*

Despite vast protest in 1970, the school board converted Gibbs into a vocational institution. The NAACP joined with the parents in dissent, claiming that the move was a ploy to prolong segregation. In 1971, the issue as well as countywide integration returned Gibbs to academic high school status. Promises of school improvement and an expanded curriculum followed. "It was not until 1975, however—after Gibbs predominantly white parents' booster club threatened to sue the school board—that the board finally began the $9.5 million improvement program," the *Times* wrote in 1980. "We were one of the few Florida black schools that didn't close during integration," said Emanuel Stewart, principal from 1958 to 1969. Gibbs avoided serious disruption during integration, but students and families were alienated. With integration, blacks felt they had lost a valuable cultural center; whites couldn't develop loyalties for Gibbs, a school so far away. All hands joined together, however, after the improvement program began. Additions including a cafeteria, a business education wing and a performing arts stage appeared. In the 1970s, a football field was constructed after the

school board committed $8 million to Gibbs. The complex was named the Newton-Williams Gladiator Memorial Field in 1971, a year after players Vincent Williams and Robert Newton were struck by lightning and killed.

In 1982 under Gibbs's second woman principal, Marilyn Heminger, the school initiated the Artistically Talented Program. The magnet program is today's Pinellas County Center for the Arts and includes performance theatre instruction. In 1990, construction was completed on the Pinellas County Center for the Arts Multi Arts Complex. One year later the structure was named for O.B. McLin. Gibbs today also features the Business, Economics and Technology Academy magnet program. In 2006, construction should be completed on a new $54 million Gibbs facility—reportedly the largest education project in county history. Some 2,300 students will benefit from the nine-building facility, which will boast a more than eight-hundred-seat theatre. "Gibbs is finally getting the kind of facility our community needs and wants," said Gibbs graduate and longest serving principal, Barbara Shorter (1991–2003), another partner in the "Miracle at Thirty-fourth Street."

Helen Dearse Roberts:
St. Petersburg's Matron of Music

Her contributions to welfare and community work are seemingly endless.
St. Petersburg Times

Standing before civic leaders including Mayor John D. Burroughs in 1959, Helen Dearse Roberts revealed her love for St. Petersburg while accepting the Woman of the Year Award. "My one prayer is that the Lord will spare me long enough to do all the things I want to do for St. Petersburg," the *St. Petersburg Times* quoted her as saying then.

After arriving in St. Petersburg in 1929, Roberts embarked on a journey to become the city's matron of music. She brought many artists to the city through her affiliation with the Carreno Music Club, over which she presided. She also presided over the St. Petersburg Symphony and was an honorary president and queen of music of the Florida Federation of Music Clubs. "There is but one name that stands above all others as synonymous with the cultural renaissance of St. Petersburg, and that is the name of Mrs. Roberts," wrote Peter Sherman, then the executive director of the Allied Arts Council of Greater St. Petersburg, in a letter dated November 1, 1962. "I consider it a great privilege being able to call upon you for counsel with regard to the St. Petersburg world of culture." Former Mayor Herman Goldner was humbled by Roberts's contributions. "We here in St. Petersburg are proud that you are a citizen of our city," he wrote in a December 6, 1961 letter to Roberts. "It is a better place because you live here."

Roberts also presided over Catholic charities, St. Anthony's Hospital Auxiliary, Women of the Chamber of Commerce of St. Petersburg and the St. Petersburg Woman's Club for eight years. She was vice-president and director of the Stephan Foster Memorial, and she granted young artists scholarships. Roberts served on numerous boards, including that of the American Legion Crippled Children's Hospital.

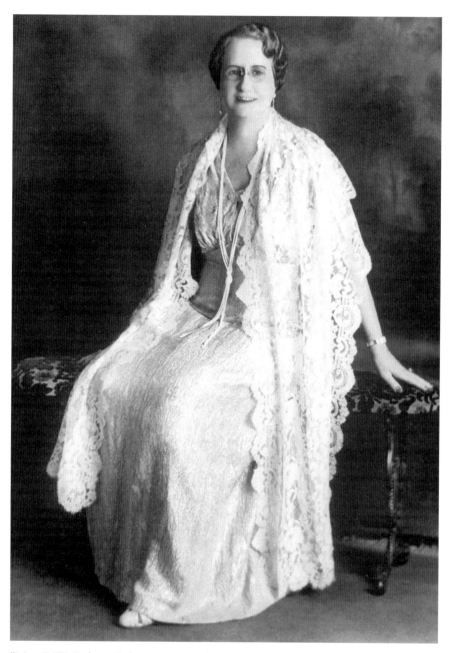

"Mrs. R.W. Roberts is known as our 'Our Angel' in the music circles of St. Petersburg, the state of Florida and the nation," Carreno President Mrs. William Wood wrote. *Courtesy Helen Rudolph and Jeannie Weber.*

Today, the Roberts Youth Center and the Roberts Music Center stand as examples of her generosity. "The great part of her persuasiveness to move others to action was her femininity," wrote Roberts's nieces, Helen Rudolph and Jeannie Weber, in a letter to this author that is preserved in his files at the St. Petersburg Museum of History. "Her non-abrasiveness softened the quick intelligence that many men of the time might have resented otherwise. [Hers was] an innate femininity—not pseudo."

Born August 30, 1880, in Oconomowoc, Wisconsin, Roberts later studied piano at the Wisconsin College of Music. In about 1915 she married Robert Roberts, who at age twenty-one had converted $20 into a $3 million a year business: the Milwaukee Forge and Machinery Co. Accompanying the couple when they arrived here in 1929 was a letter from Wisconsin Governor Julius P. Heil that was shared by Rudolph and Weber with this author. It began: "This will introduce you to Helen Dearse Roberts, a highly respected citizen of Wisconsin." After settling at 435 Seventeenth Avenue Northeast, Roberts became the right arm of the Carreno Music Club. "When they asked me to be president, I said I'd agree if they let me bring in outside artists," the *Times* quoted Roberts in 1968. "[Artists] were needed. At the time there was no symphony or any other musical organization." Roberts served as Carreno's president for eight years and introduced talent to the Sunshine City, including soprano Shirley Verritt and pianist Lorin Hollander. Roberts donated $1,000 and AT&T stock to the National Federation of Music Clubs and served as its board member for forty years. The Helen Roberts Scholarship Fund helped boost the careers of local talent.

"Mrs. R.W. Roberts is known as 'Our Angel' in the music circles of St. Petersburg, the state of Florida and the nation," wrote Carreno President Mrs. William Wood in a letter dated January 13, 1962. "In St. Petersburg she is always at the helm, steering the 'Music Ship' in the right direction—no matter how stormy the waters. She contributes thousands of dollars and countless hours of her time each year to the advancement and encouragement of better music." About 1939 Roberts moved to 515 Brightwaters Boulevard, today the residence of Roberts's nieces, Weber and Rudolf. After her husband's death in 1950, Mrs. Roberts became the Milwaukee Forge and Machinery Co.'s director and donated $20,000 to purchase land in her husband's name for a youth center. In 1958, the Roberts Youth Center was dedicated at 1246 Fiftieth Avenue North. A new nearly $5.5 million center is planned for completion in 2007. The future 27,000-square-foot center will combine youth and adult activities.

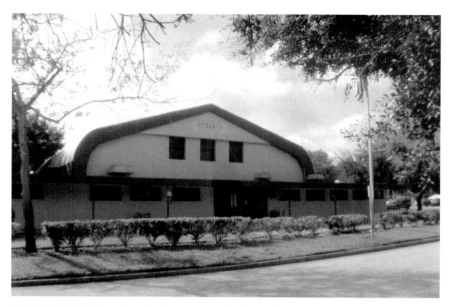

In 1958, the Roberts Youth Center was dedicated at 1246 Fiftieth Avenue North. *Courtesy St. Petersburg Museum of History.*

On January 30, 1959, Roberts—known for her hats, gloves and fifteen-minute power naps—was named "Queen of Hearts" at the Coliseum's annual Heart's Ball. Nineteen days later, residents filled the First Federal Bank's Friendship Room to honor Roberts after an anonymous committee voted Roberts St. Petersburg's Woman of the Year. "Her contributions to welfare and community work are seemingly endless," reported a 1959 *Times* article about Roberts, whose chauffeur-driven black limousine was widely recognized around the city. In the late 1950s and early 1960s, Roberts funded parking lot construction and the Twelfth Street overpass at St. Anthony's Hospital. She also gifted a traction table to the hospital's physical therapy department and provided the facility with an amplifying system. In gratitude, the hospital named its gift shop in Roberts's honor.

In 1962, Roberts was named the city's outstanding citizen. Northeast High School dedicated its nearly $67,000 pool that same year in Roberts's name. Her benevolence to Northeast St. Petersburg children inspired the school to name the pool the Helen Dearse Roberts and George Stovall Sr. Pool, the county's first such school resource. Also in 1962, Roberts funded broadcasts of the St. Petersburg Symphony on local television for residents unable to attend concerts. "I felt impelled to write a word of thanks for this and all the other contributions you make to music,"

wrote an anonymous resident in a letter written on New Year's Eve 1963. "This makes a bright, warm spot for many of us who love and appreciate music. I feel as if I know you."

In 1966 Roberts donated $378,000 for the Roberts Music Center's construction at Florida Presbyterian College (FPC), today's Eckerd College. She was later surprised at the Bayfront Center, when FPC's President William Kagel awarded her a replica of the college's mace. Roberts was celebrated again in 1967, earning the city's Outstanding Citizen Award for the second time. In 1968 Roberts, who was an honorary president of both the Wisconsin and Florida Federation of Music clubs, provided FPC with another $30,000 for an Austrian-made organ. The St. Petersburg Symphony, which Mrs. Roberts once boosted with $35,000, considered Roberts the queen of music. In 1969 Roberts, who provided $275,000 to build St. Raphael's Catholic School, received papal acknowledgement for her civic involvement. "I admired her when she offered housing to a [black] opera star slighted by discrimination," said former *St. Petersburg Times* classical music critic Mary Nic Shenk Dodd.

Wearing ivory lace, rope pearls and diamond pendant earrings while talking continually on August 15, 1970, Roberts celebrated her ninetieth birthday with more than three hundred guests. Banker Oscar Kreutz, Mayor Don Spicer and Bishop Charles McLaughlin attended the celebration. "We salute her many contributions to the enlightenment of our citizens," *Times* editor Donald Baldwin said, while making Roberts the first woman recipient of the *Times* Stick of Type Award for her community service. After the speeches, Miss St. Petersburg Melinda Jones exited a papier-mâché cake that was blanketed with ninety candles. "Roberts bore herself like a queen [that night]," Peter Sherman said.

On September 3, 1974, Roberts died at age ninety-four. The *Times* called her "an outstanding music and community patron and the greatest music philanthropist St. Petersburg has known." A year later, unaware of Roberts's death, the archbishop of Durban, South Africa, the Reverend Denis E. Hurley, wrote her an April 30, 1975 letter of thanks for her earlier help with the Weenen clinic. "Something of you is at Weenen, Mrs. Roberts, something of your love, your compassion, your generosity. Please keep up your wonderful help."

Albert Whitted Airport:
Toiling Through History

Many people who know the airport's history see its struggle as a David and Goliath thing.
 Sheri Weaver, Albert Whitted operation supervisor

After traveling fifty thousand miles while touring the nation in March 1930, a flying grocery store taxied into Albert Whitted Airport. A galaxy of residents gathered to witness the event, thrilled that the craft was staying that entire Monday. "The tri-motored Ford *Independence*, the flying grocery of Reid, Murdoch, & Company, makers of Monarch Foods…was viewed by thousands," the *St. Petersburg Times* wrote then. "A special runway [was] erected along the side of the plane, making it possible for spectators to see the interior of the pilot's cockpit as well as the food display."

After its opening in 1929 Albert Whitted also housed Goodyear blimps, navy aviators and a plane that resembled a bat. It was the first home for National Airlines. Today the facility quarters nearly two hundred aircraft, and in 2005 it handled seventy-nine thousand operations. But from 1958 to 2003, Whitted has fought an uphill battle for its very existence as developers and politicians have questioned the airport's waterfront value. "Many people who know the airport's history see its struggle as a David and Goliath thing," said Sheri Weaver, the airport's operation supervisor. "Albert Whitted has such a personality. There's something about it. Maybe it's the white and blue lights at night. Of the people who have learned to fly at Albert Whitted, many have given a lot to the airline industry."

In 1910 using a dredge named after his daughter Blanche, W.L. Straub began the work to deepen the Port of St. Petersburg on the city's waterfront. One year later the city purchased the north half of waterfront lot number nine from Kittie H. Springstead for $5,000. A

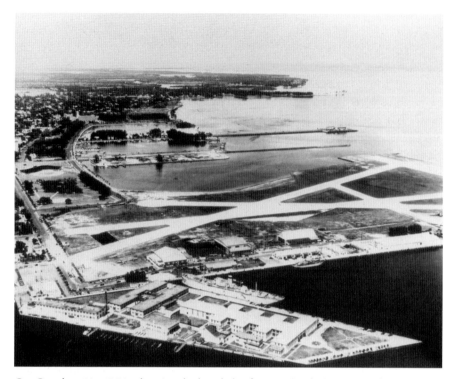

On October 12, 1928, the city declared the former Cook-Springstead tracts Albert Whitted Airport. Above is an aerial view of the airport taken in 1945. *Courtesy St. Petersburg Museum of History.*

hangar was built there, from which aviator Anthony Habersack Jannus later operated. On New Year's Day 1914, Jannus piloted former Mayor A.C. Pheil across the bay and into Tampa. "This was the first [paid] scheduled commercial flight in the world," said Bill Buston, a Florida Aviation Historical Society board member. A Florida Historic Site marker near the airport today acknowledges that first flight. After a $15,000 additional land acquisition from Marguerite Cook in 1917, officials envisioned a city airport. Mayor John Brown empowered an aviation committee in 1928. On October 12 of that year, the city declared the former Cook-Springstead tracts Albert Whitted Airport. The field, the city said, would be ready for outgoing and incoming planes by early 1929. "He probably would have taken the naming with a grain of salt," said Dr. Eric Whitted of his Uncle Albert, who perished with four others in an air crash on August 19, 1923, near Pensacola. His wife and two children survived the young pilot. "He was a genius and very humble."

In summer of 1929, an eighteen-hundred-foot east-west shell runway was constructed at Albert Whitted. "St. Petersburg, a future world airport," the *Times* wrote that year. "This city possesses every fundamental requirement for world-wide air transport. The records of the weather bureau...give this section the highest percentage of clear flying days of any locality in the world. Time will see passengers leave big steamers at St. Petersburg port and board great airliners for all parts of the world." In September 1929, city promotional director John Lodwick wrestled $33,062 from city council to construct a blimp hangar at Albert Whitted. Three months later, Lodwick convinced the Goodyear Tire and Rubber Co. to house its airships at the airport. The airship *Vigilant* arrived December 10, 1929, accompanied by a ten-plane escort. Members of nearly every local family turned out; the blimps *Mayflower*, *Puritan* and *Resolute* followed. After the Depression deflated Lodwick's airship promotion, the hangar housed airplanes and became a storage facility, a maintenance shop, a photography studio and a Florida Power flight headquarters.

At 6:00 a.m. on October 15, 1934, with five employees and three Ryan Aircraft Broughams, National Airlines System launched its inaugural mail flight from Whitted. Ryan Aircraft had earlier constructed pilot Charles Lindbergh's *Spirit of St. Louis*. National's first flight traveled 110 miles per hour to Daytona Beach, with National's owner George "Ted" Baker aboard. Three Stinson Trimotor planes, all of which seated eight passengers and three crewmembers, later expanded National's flying force. These Trimotors of National Airlines traveled up to 125 miles per hour and their pilots carried guns. "Management called our route the Route of the Buccaneers," said Hank Palmer, a former National mechanic. By 1938, Albert Whitted housed about $150,000 in aircraft and was considered Florida's second busiest flying field. Once National's flights extended outside of Florida, the company grew considerably. In 1940 Baker relocated his airline to Jacksonville, and the enterprise became a leading passenger airline. In memory of the airline company today, National Airlines Avenue Southeast borders Albert Whitted Airport.

About 1940, a bat-like plane that traveled 110 miles per hour and eased into landings at 20 miles per hour captivated Albert Whitted's visitors. Many locals called it the *Bat*, and many claimed the plane looked like a flying saucer. A four-cylinder, ninety-horsepower motor powered the *Bat*, which had a cotton fabric cover and a twenty-two-foot wingspan. On January 7, 1941, the craft crashed near the airport and killed its pilot. Today's F-100s and the space shuttles pay tribute to the *Bat* by imitating

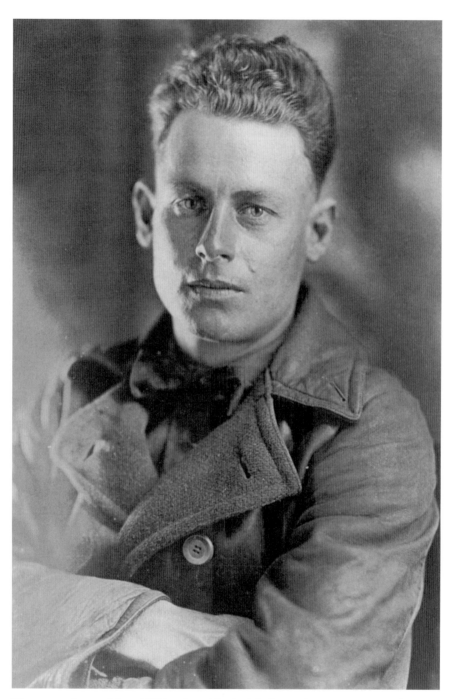

Lieutenant James Albert Whitted perished with four others in an air crash August 19, 1923, near Pensacola. *Courtesy St. Petersburg Museum of History.*

its design. From 1941 to 1944, Albert Whitted hosted the War Training Service program for navy aviation cadets. After the program closed, banker Harry Playford established U.S. Airlines at Albert Whitted. The enterprise carried freight and ran charter flights until it moved in 1948 to the site of today's St. Petersburg-Clearwater International Airport. In 1945, Bay Air Flying Service Inc. established itself at Whitted with just a "couple of planes," said Ron Methot, the company's current owner. Today the concern has thirteen planes and ten instructors. Bay Air graduates about fifty pilots annually.

In 1958, with Albert Whitted's land valued unofficially at $2.5 million, City Manager Ross Windom lobbied for the airport's closure and touted a plan to redevelop the site. The airport's pilots formed the St. Petersburg Aviation Association and quieted Windom, only to see another redevelopment effort surface in 1963. "Proponents of closing down the airport argue the site just south of South Waterfront Park is too valuable for the exclusive use of a privileged few [who fly the seventy-two planes that are based at Albert Whitted]," wrote the *Independent* in 1963. The drive to close the airport that year failed. Seven years later in 1970, the *Independent* reported that an effort to rename the facility Eisenhower International Airport in honor of our thirty-fourth president was quickly quashed. "I'm definitely against it," said Horace Williams Jr., a city council member and great-grandson of founding father J.C. Williams. "Albert Whitted was a [city] pioneer."

In 1984, city council overruled its own subcommittee and agreed to preserve Albert Whitted. "The city has always treated the airport like an unwanted stepchild," Palmer said. "Cities need airports like they need streets." In 1999 the historic blimp hanger was razed and relocated. Four years later controversy erupted again when Mayor Rick Baker proposed to shrink the airport and eliminate one runway. Albert Whitted supporters countered the move by supporting a referendum to save the facility permanently. In November 2003, Richard Lesniak was hired as the airport's manager. "Once he was on board at Albert Whitted, airport improvement projects and funding dollars were identified and the groundwork for future development began," said Weaver about Lesniak, former head of airport operations at St. Petersburg/Clearwater International Airport. Currently, Whitted is awaiting city council's approval of its master plan. Future plans include new illuminated airfield signage. Numerous hangars—including hangars one, five and eight—will be given a fresh coat of paint, new roofs, doors and door wheels. A new control tower is in Albert Whitted's future, made possible by a Federal Aviation Administration grant. By the end of 2006, Whitted should be

sporting a new 10,600-square-foot, two-story terminal building located in the northwest corner of the airport.

"The entire second level will be a restaurant with open areas overlooking the airport," Weaver said. "Conference rooms and other office space will occupy the downstairs area."

Glen Dill:
The Sunny Side of
St. Petersburg's Mornings

Dill called people by their first name. He'd sit at Fifth Street and First Avenue South on a green bench and talk to people.

<div align="right">Resident Don Saxer</div>

While jawing to Sunshine City residents on WTSP radio one morning, broadcaster Glen Dill screamed out for a thick, juicy steak. A short time later, as the narrative goes, he received a phone call from the proprietor of a restaurant tucked away in Ocean City, New Jersey. "Your steak is on the fire," she said.

From 1943 to 1957, Dill's madcap radiobroadcast received responses from seventeen hundred cities representing every state and fifty-three foreign countries. It took forty-eight scrapbooks and forty-two admirers to assemble Dill's more than three hundred thousand fan letters. One scrapbook weighed twenty pounds; his gifts from devotees filled a room. There was a zither, a fur-lined bathtub and a vocal duckbill platypus—reportedly the first brought into the country. After the platypus died, Dill had the animal stuffed and mounted and referred to it fondly. "We tuned in the radio today to hear Glen's morning program on WTSP," reads an excerpt dated January 11, 1946, from the diary of Florence Block, Dill's sister. "Same corn."

Dill's celebrity guests—including Gertrude Lawrence, Charlie Chaplin, Edward Everett Horton and Lawrence Welk—drew listeners. But it was Dill's hackneyed advice and outlandish gags that attracted ears to his *SunDial* program, one of Florida's oldest radio features. "I do believe you are the craziest man in the world," a fan wrote to Dill, the *St. Petersburg Times* reported in 1948. One Dill antic involved his answering a dare to eat breakfast at Maas Brothers clad in a red flannel nightshirt. Such outrageous behavior gained Dill the love of numerous Sunshine City bobbysoxers. "I took your picture to school," wrote one teen according

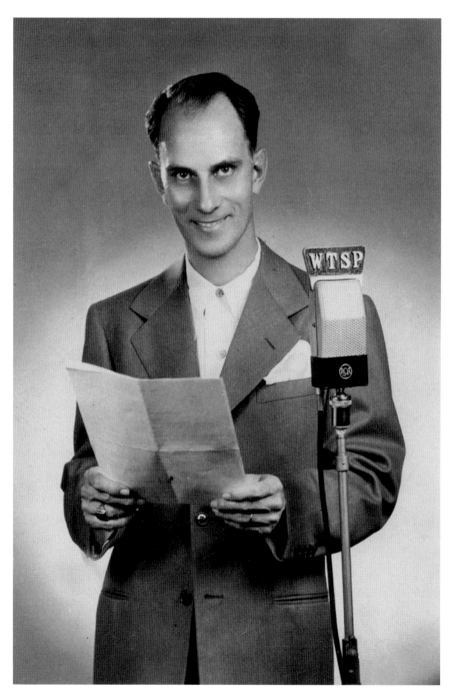

One Glen Dill gag in the 1940s involved the housing of tadpoles in his bathtub. Listeners called to check on the stock. Dill later revealed that the frogs were fictitious. *Courtesy Glen Dill's family.*

to a 1948 *Times* piece, "and all the girls swooned." Another student wrote, "You remind me of Van Johnson. Sing it to me, Glen."

"The guy is good," journalist Dick Bothwell said in his 1948 *Times* column about Dill—also an author, historian and environmentalist. "There's never a droopy moment on the program. Dill's best may be hammy but it's homey—in chatty informal adlib style, he kids his listeners and himself."

Born in 1910, Dill later worked after school as a theatre page where he met stars including Mae West and Ronald Coleman. He then entered the hotel business where he worked as a bellboy, room clerk and manager in cities from Houston to Buffalo. The Cleveland native came to Florida in 1934 on a whim with an acquaintance and toured the state. He said he knew the minute he arrived in St. Petersburg that it was for him. During the summers here, Dill clerked at the Concord Hotel. In 1943 when all hotels except for the Suwannee were under government control and reserved for recruits, Dill interviewed at WTSP ("Welcome to St. Petersburg"), a station owned by *St. Petersburg Times* editor Nelson Poynter from 1939 to 1956. "I just decided I'd like to audition," Dill told the *Times* in 1953. "Walked into WTSP and read 20 minutes of copy, cold. I started working as an announcer the next day, and took over the *SunDial* a few months afterward."

One Dill gag in the 1940s involved the housing of tadpoles in his bathtub. For eight months, listeners called to check on the stock. Sometime after Dill claimed that he released his swimming brood at Mirror Lake, he revealed that the tadpoles were fictitious. "He was a tremendous storyteller," Peggy Pennington said of her Uncle Glen, who loved golf and loud shirts and owned forty-seven hats. "He was an uncle who was always interested in us. I remember his singing. He would sing to me on the steps of my home. Good voice." Dill fan Sandra Grant often witnessed the witty disc jockey in action. "I grew up in St. Pete and would probably be classified as a groupie," said Grant, now a Summerfield, Florida, resident. "As a junior high student, I was in the WTSP studio every Saturday morning with Glen as he played his theme song, 'Sunrise Serenade,' to open the *SunDial*. Many a morning he would give me a large bill (often a $50) and send me over to buy candy from a store on First Avenue North. It was the Princess Martha Candy Store or something like that. We always talked about his duck-billed platypus. He would let us help announce music or read something on the air. He was wonderful with the young people. Radio was wonderful then for me. Such wonderful memories."

Dill was a part of the daily routine for longtime resident Lon Cooper and his wife, Dot. "Glen Dill was a household word in St. Pete for many

years," Cooper said. "Our day started with Glen. While Dot prepared the children for school, I got ready for work. Glen was upbeat. You felt like you knew him as a friend. It was a great way to start the day." Often Dill's broadcasts reunited dogs, cats and even goats with their owners. "The nanny was wandering in our yard early one morning and a call to Glen produced results in about ten minutes," Cooper said. "The owner arrived later that morning. He scolded the goat in a friendly way, and she seemed glad to see someone she knew."

In 1945, Dill married Josephine Mays. The couple had one son, who died in an auto accident in his early twenties. "I think he missed seeing what his son could become," Pennington said, "and having grandchildren." Through three wars Dill used the airwaves to keep servicemen and women in touch with their families, earning him a government citation. The U.S. Army later cited Dill for his radio program *Little Egypt*, which helped fight malaria at tropical army camps. After the first woman was sworn into the Air Force on his show, Dill continued aiding recruitment and was honored by the military branch. A flippant remark by the broadcaster in 1950 about the "easy life of a housewife" led females to demand the broadcaster experience the hardships of housekeeping by making a temporary job switch with his wife. The Dills traded responsibilities on October 5, 1950. Both found the experience eye-opening, and Mrs. Dill was complimented on her radio skills. Listeners loved the antic and bonded with the Dill family. "Dill called people by their first name," said resident Don Saxer. "He'd sit at Fifth Street and First Avenue South on a green bench and talk to people."

In 1955, "Colonel" Tom Parker asked Dill to invest $5,000 in Elvis Presley. "I don't know," Dill said in response, according to a 1977 *Times* story. "I don't think he's quite worth that much. He can't sing that well, and he isn't a good guitar player. That wiggling stuff seems to be pretty good and seems to attract the girls. But how long can that last?" After recalling the happening, Dill's niece Carol Presti said: "Boy did he kick himself in the butt for that one. He thought there were so many of those kids back then. He could have been a rich man."

Dill left WTSP in 1957 to join St. Pete Beach's WILZ as director of public relations. Four years later, Dill was general manager of St. Petersburg's WTCX radio. In 1963, Dill relocated to New Port Ritchey and became the first voice of WGUL. He later toured Florida, culling the state's history. His column highlighting his experiences, "Disa and Data by Dill," appeared in the *Suncoast News*. "You know, everywhere I go people know me and I know them," Dill, a former librarian and West Pasco Audubon Society president, told the *Times* in 1975. Presti said that during his travels Dill would

Glen Dill relaxes in a room decorated with gifts from his fans. *Courtesy Glen Dill's family.*

encounter "so many people [who] would approach him and say, 'Aren't you Glen Dill?' His chest was just swelling. He was a very learned man. Gave many lectures over the state about ecology and history. He was very slender, tall. I don't ever remember him having a lot of hair. Very generous, gave boxes of things for Christmas. He always had a joke for you."

By 1986 Dill had written some eleven hundred columns and placed eighty of them in a book titled *The Suncoast Past.* The book was available in locations including the Pasco-Hernando Community College, where Dill housed his memorabilia in a room named after his wife and son. Dill's collection of memorabilia is now at the Poynter Library at the University of South Florida St. Petersburg campus. "He was always interested in life and learning about people," Pennington said. "Always trying to keep up with events. In his later days he used to say, 'I'll look forward to each day and what it holds.'"

Dill died in 1993 at age eighty-three. Resident Mary Christian recently reflected on Dill and the power of radio, back when listeners were drawn to the zany broadcaster like a pack of hungry squirrels to the city's last nut. "Radio was more local and personable [then]. It was welcome in your home, and broadcasters were like old friends. I don't know when we lost that."

R.W. Caldwell Sr.: Pinellas's Trusted Realtor and Politician

If this town is to avoid refinancing…it must grow! Its financial affairs must be administered carefully, yes frugally.

R.W. Caldwell

In need of strength and guidance in 1949, the members of the St. Petersburg Board of Realtors elected R.W. Caldwell Sr. as their president. "Caldwell was a people person," said Betty Barrs, whose husband Merton was a builder who worked with Caldwell on numerous homes in St. Petersburg and Gulfport. "He was civic minded; a good businessman. Had a reputation for being fair with people." Caldwell's granddaughter, April Caldwell Hornsleth, said the realtor "had the natural gift of leadership and knowledge of his honesty was widespread. He always had some deal going."

Shortly after coming to the area, Caldwell earned waves of thanks from local beachgoers for sparking the drive to dredge Gulfport's shore from Fifty-fourth to Fifty-eighth Streets South to create the beach. "I, like many other people, thought that the city would be immensely benefited by an improved beach," Caldwell wrote in a 1941 brochure preserved at the St. Petersburg Museum of History in this author's file. "We had a lot of opposition." Before becoming the father of Gulfport's beach, however, Caldwell established a real estate concern here. He created a listing of area homes for sale that realtors in St. Petersburg and Gulfport could share, bonding the land peddlers of both communities.

Caldwell later co-owned the *Gulfport Tribune* newspaper. For four years, Caldwell served on Gulfport's Town Council and led an effort to salvage the city's economy. "He definitely got Gulfport [economically] strong. I'm proud of him," said Elise McCarthy, Caldwell's granddaughter. Resident Colleen Camp, who served on the Gulfport Council from 1990 to 1998 before passing away in 2003, said of Caldwell: "He was very

R.W. Caldwell, the red-haired realtor, gained notice about 1937 by placing green benches bearing his name around Gulfport. *Courtesy R.W. Caldwell Sr.'s family.*

much involved in the activities of Gulfport. Very much into the building of the city." Today, Caldwell's enterprise located at 5201 Gulfport Boulevard is the oldest business in Gulfport.

In 1888, Caldwell was born in Belleview, Wisconsin. At Knox College in Illinois he was the debating champion amid a school of debating champions. Caldwell financed his education by selling stereographs and stereoscopes for Keystone View Co. of Meadville, Pennsylvania. Stereographs were photos that displayed a 3-D image when viewed through stereoscopes. By 1913, Caldwell had graduated from college and married Gail Jarrell. About then, he became Keystone's western sales manager. "He was a proven leader in the sales business and in the training of sales people," said R.W. Caldwell Jr., one of two Caldwell children. About 1930 near Cleveland, the nearly six-foot tall Caldwell established Keystone View of Ohio. He then joined hands with photographer George K. Lewis to produce aerial stereographs of the 1933 Chicago World's Fair. One year later, Mrs. Caldwell came to Gulfport to recover from a streptococcus throat infection. Caldwell then closed his Keystone View of Ohio location, opened a Keystone outlet near Boston and often visited his wife. He moved to Gulfport about 1935 and settled on Seventeenth Avenue South. "Mrs. Caldwell and I have decided we want to live in Gulfport for the rest of our lives," Caldwell wrote in the 1941 brochure cited earlier.

In 1936, Caldwell invested with E.A. Markham to form a Hartford Insurance and real estate concern, Markham-Caldwell. "The easiest money you'll ever make is the money your money makes," Caldwell often advised, said R.W. Caldwell Jr. Within a year Caldwell established R.W. Caldwell, a similar business at the same 5433 Shore Boulevard South address. The red-haired realtor gained notice by placing green benches bearing his name around Gulfport. "I built some of them," R.W. Caldwell Jr. said. "Placed them all around the city." The junior Caldwell added that his father placed signs throughout the city at his own cost that boasted "You Can Really Live in Gulfport." By 1938, Caldwell had sold his home in Meadville, Pennsylvania, for $11,000. Former longtime Gulfport resident Nathan White said, "Caldwell was an energetic, honest, hard-working man." White, who met the realtor at age fifteen and knew him about thirteen years, said that Caldwell was "an asset to the community. He always waved and was gracious. The Caldwells were good for Gulfport, and Gulfport was good to the Caldwells."

After his election to the council in 1939, Caldwell proposed dredging the beach. Dredging costs then were about twelve cents per cubic yard,

In 1939, Caldwell Sr. began the dredging of Gulfport's beach. *Courtesy R.W. Caldwell Sr.'s family.*

compared to about fifteen dollars per cubic yard today. The estimated cost of the dredging then was $3,000; the city pledged to pay half. Caldwell raised $1,800 for the project. According to R.W. Caldwell Jr., however, the city reneged on the deal after heated discussion during which Acting Mayor Cliff Hadley and Caldwell reached opposite points of view. "He [Caldwell] was on the outs with Hadley," Caldwell Jr. said. Caldwell and others then financed the project themselves, which ultimately cost $2,700. The city later praised Caldwell as the father of its beaches. "The beach as you know it is what he created," R.W. Caldwell Jr. said of his father, who in the early 1940s owned 19 of the city's 777 houses and apartments.

As the council's finance chairman in 1940, Caldwell refused to add to the city's debt. "This indebtedness is a menace to your property and mine," he wrote in that same 1941 brochure. Caldwell said then that the town couldn't buy a dime's worth of nails without first laying down the dime. So Caldwell initiated a program similar to one that Pinellas County's first school Superintendent and State Representative Dixie M. Hollins had established earlier in St. Petersburg. Caldwell's program was spread out over ten years, and it repaid the nearly $1.6 million debt to area merchants who had supported Gulfport financially. "Due to

Gulfport's excellent financial record with the refunding program, our bonds today cannot be bought for less than ninety-eight cents on the dollar," Caldwell wrote in a series of financial notes in 1950, preserved at the St. Petersburg Museum of History in this author's file. "The reason for Gulfport's financial success with their refunding program has been [the city's] phenomenal growth. You drive by whole streets of new houses, all building records have been shattered."

On July 17, 1942, Caldwell and seven others including his former business associate E.A. Markham purchased the weekly *Gulfport Tribune*. Caldwell became the four-page newspaper's acting editor. "Gulfport needs its own newspaper and the newspaper needs you as a subscriber," Caldwell wrote in the *Tribune*, after slicing annual subscription rates from two dollars to one dollar. "We are in the peculiar position of being a most excellent suburban community." Caldwell's name last appeared as acting editor on November 12, 1943, the same year he completed his last term as a council member. In the early to mid-1940s, Caldwell founded the St. Petersburg Multiple Listing Service Inc. Caldwell's listings allowed realtors in St. Petersburg and Gulfport to share information regarding vacant homes. Today the concept is still used by realtors, who pull up the service online. Gulfport resident and former contractor Bill Mills remembers Caldwell in the 1940s as a big man and a solid salesman. "He believed that if you designed the homes to appeal to the ladies, they would sell," Mills said. In 1949, Caldwell was elected president of the St. Petersburg Board of Realtors. As president he continued to bridge St. Petersburg and Gulfport realtors together in an effort to provide improved assistance to homebuyers and increase home sales. By the late 1940s, Caldwell was on the board of governors of the Florida Association of Realtors. "I think most people of the area were thankful they had someone of Caldwell's caliber here," said Gulfport resident Jane Palmer, who met the realtor in the early 1940s.

About 1950, Caldwell paid $18,421 for a beach home at 3111 Fifty-third Street and moved his office to 3119 Beach Boulevard South. April Caldwell Hornsleth remembers sitting in a green chair sharing sherbet with her grandfather Caldwell, who then was sans any gray amid his head of red hair. That chair is now at the Pontiac Apartments owned by Hornsleth and her husband Poul, who today are the third generation to operate Caldwell Realtors. In 1952, Caldwell had just completed a term as president of the St. Petersburg Board of Realtors when he began to lose his ability to speak. He died that year of cancer of the esophagus at age sixty-four. Hornsleth wasn't told of her grandfather's death until months later because of her age, then four. "I would visit

and go looking for him," said Hornsleth, the self-proclaimed apple of Caldwell's eye. In December 1955, the council voted unanimously to honor Caldwell. About one year later, a fountain in his name was placed at the pier entrance. "We had the whole family there" at the dedication, R.W. Caldwell Jr. recalled. "I think I even had a suit coat on." By then, Hornsleth was about age seven. "I guess I felt pretty important at the time," she said. "All my cousins were there."

Thomas Dreier:
An Idea's Best Friend

Gifts to colleges should be as free as the minds of the professors.
 Thomas Dreier

Throughout his life, Thomas Dreier scoured libraries for ideas. He believed ideas were the foundation of universal truth. And it was libraries, he discovered, that protected ideas like a fortress. "Public libraries are idea stores, idea banks, idea repositories," the philanthropist, lecturer, author, editor and publicist told the *St. Petersburg Times* in 1955. "They offer our citizens the recorded, organized life experiences of the race. Ideas are the most important element in personal or business success. Not money. Not machinery. Not buildings. Just ideas."

After arriving here in 1935, Dreier helped found the St. Petersburg Friends of the Library locally and statewide. He later initiated the drive here for a main library. "The new library will be a monument to fifteen years of tireless effort by Tom Dreier," the *Times* wrote in 1963, when the library neared opening. "This means that this community has now matured culturally to the point where residents who came here in adult years from somewhere else no longer need to make their philanthropic gifts or bequests to northern institutions." Dreier wrote numerous trade publications and authored nine books. When racism raised its ugly head at Florida Presbyterian College (now Eckerd College) in 1965, Dreier came to its aid. He considered himself a vagabond and a pagan. "[I'm] one who wanders seeking truth and beauty and who makes known his discoveries to others," Dreier, who was often paid weekly by Studebaker's president to discuss business savvy over lunch, told the *Times* in 1972. "I wandered through books and passed on the thoughts I found in them. I wandered through men and passed on the thoughts I found in them."

At age four in 1888, Dreier encountered prejudice when it forced its way into his home in Durand, Wisconsin, on a cold November night.

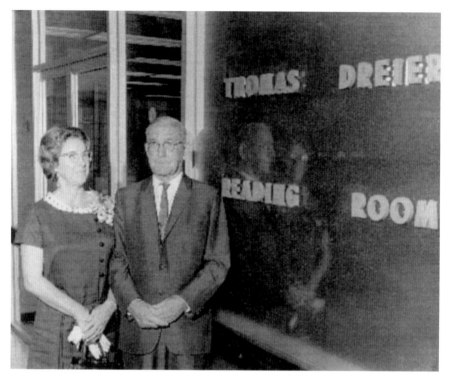

Thomas Dreier and his wife Mary stand before the Thomas Dreier Reading Room during the room's dedication in 1967 at the campus library, then the William Luther Cobb Library. *Courtesy Eckerd College.*

There was a loud crash, followed by what sounded like numerous mirrors falling to the floor. Then came the crying. "I woke up and heard my mother sobbing in the next room," Dreier revealed to the *Times* in 1970. "She came in and said, 'Don't get up you'll cut yourself on broken glass.' I put my hand out, and there was glass on the covers. A mob had surrounded the house and broken every window. My father's crime was he, a good German boy, had married an Irish girl." By high school Dreier had written for the *Durand Weekly*, discovered the works of Ralph Waldo Emerson and forsook a desire for the priesthood. *Who's Who* says that in 1902 after his graduation, Dreier began "a vagabond life…specialty salesman, bartender, millhand, barber, waiter and foreman of a printshop." Dreier then reported for the *Menomonie* (Wisconsin) *Times*, the *Madison Democrat* and the *Wisconsin State Journal*. He edited the *Sheldon School of Salesmanship* newspaper in Chicago. By 1910, he was the managing editor of the Boston magazine *Human Life*.

While in Boston he established the Thomas Dreier Service, through which he wrote practical and philosophical publications for businesses. The *Times* later called Dreier one of the nation's first and best public relations men. "I saw that businessmen were the influential people," Dreier said in his publication in 1970. "If I can influence the thinking of these people, it would be like turning on a master switch to light up a thousand lives. I thought of readers as fellow human beings, not customers. I wrote as if I was the head of each company." Instead of decrying unfair labor practices, Dreier convinced businessmen that their employees would produce more under a pleasant environment. He regularly published twenty-seven various pamphlets laced with inspiration and philosophy. After a three-week courtship in 1914, Dreier married "Snug" Blanche Nowell. She combined and invested her millinery profits and those from Dreier's writing, amassing a fortune. With Snug's financial help, Dreier grew his New Hampshire home business into a more than twenty-client enterprise with a staff of seven. Snug's arthritis brought the couple here in 1936 to spend their winters at Snell Isle's 1011 Brightwaters Boulevard. From there Dreier continued working and authored *Sunny Meadows,* a book about life on his five-hundred-acre New Hampshire farm.

In 1947 Dreier led nine others to found the St. Petersburg Friends of the Library, a group dedicated to the development of a central library with branches. "We are still functioning with [Dreier's] money," said Bethia Caffery, current Friends of the Library president. As a journalist with the *Evening Independent* in 1972, Caffery had characterized Dreier as a man who "listens to ideas, and his eyes shine." Governor LeRoy Collins appointed Dreier in 1955 to the State Library Board. Two years later, Dreier said that with state aid St. Petersburg could have a ratio of two books per person—instead of the three-quarters of a book per person that the city held then. Without aid, "we will be continuing to carry a one-hundred ton load with a one-ton truck," Dreier told the *Times* in 1957. By 1960, Florida still ranked thirty-seventh in the nation in providing library services to its residents. One year after Snug's death in 1960, Dreier married Mary Baker, who assisted in and encouraged his endeavors. He was elected in 1963 as president of the Florida Library Association, becoming the first non-librarian ever to head the organization. Through it all, Dreier said that he prayed that he would be loved and useful. During the cold war, as chairman of the Florida State Library Board, Dreier said that the Soviet Union was seeking to dominate the world with its knowledge. They won't need sputniks or missiles, he warned in the *Times* in 1960. "There are 734 books for

every 100 inhabitants of the USSR," Dreier wrote. "There are 394,000 libraries of all types [in the USSR]. Brace yourself for a shock. [America has] only 25,000 [libraries]. Of these, only about 7,500 are public. Florida ranks 37th in the nation in availability of library service to its people. We must not let Russia or any other nation surpass us in the creation and use of mental capital."

On a February Sunday in 1964, Dreier was praised for his fifteen years of support during the dedication of St. Petersburg's first central library at 3745 Ninth Avenue North. He then gave $20,000 to create the Blanche Nowell Dreier Garden behind the $1 million structure. Ceremonies included entertainment by the Northeast High School band and the raising of the library's flag. "This is a dream come true," Mayor Herman Goldner said, reported the *Times* in 1964. The mayor then praised Dreier and Mrs. Edwin Kelly, then president of the Friends of the Library. "Without their efforts we wouldn't have a library."

When three Florida Presbyterian College affiliates attended the Freedom March on Selma in 1965, twelve conservative supporters threatened to terminate their financial aid to the college. The *Times* responded in 1972, calling the threat a crisis for a school possessing the tenuous finances of FPC. Dreier held a press conference at his home. It's "academic blackmail," the six-foot tall Dreier declared, reported the *Times*. "Gifts to colleges should be as free as the minds of the professors." He then gave $100,000 to FPC, doubling the amount he had given years before. "[FPC] should have been called Dreier College," said author June Hurley Young, who after meeting Dreier about 1958 was inspired to write her local histories. "He loved all mankind, be they conservative or liberal."

At age eighty-one in 1969, Dreier was still waking at 5:30 a.m. daily to play eighteen holes of golf. He would return home and answer his correspondence, dabble in editing and complete work with local libraries and Florida Presbyterian College. In 1972, Dreier received the *Times* Stick of Type Award for his outstanding contribution to the city. By 1972, Dreier's eyesight had deteriorated. He had quit golfing and had begun biking nearly fifteen miles daily, collecting litter in a bag and bemoaning man's venture into space. "They'll be flinging beer cans and banana peels from the windows of their space ships, putting an endless stream of garbage in orbit to circle our globe forevermore," Dreier, a passionate environmentalist, told the *Times* in 1971. "Shed a tear for outer space, my friend. It is doomed."

In 1976 at age ninety-two, Drier died in his home at 701 Brightwaters Boulevard Northeast.

Dick Bothwell:
St. Petersburg's Bundle of Joy

Women will look me boldly in the eye and say suggestive things like have a nice day, which is obviously a come-on.

Dick Bothwell

On a March day in 1979 journalist Dick Bothwell stood tall, faced a crowd and radiated twice his normal joy. "The world is also celebrating Albert Einstein's 100th birthday this week," the *St. Petersburg Times* quoted Bothwell, who was celebrating his fortieth anniversary as a writer with the newspaper. "This seems highly appropriate, since I have always felt [Einstein and I] had much in common. In 2017, I will be 100 and writing better than ever. At that time I will do a dandy piece."

For forty-two years, Bothwell brought laughter to locals as an author, public speaker and newspaper columnist. "He reminded me of [humorist] Will Rogers," said Don Addis, former *Times* cartoonist. "He was from the old school. The Mutt and Jeff school. Moon Mullins. He was one of the first people I met here. I inherited his candy jar and put his picture on it. Dick always had a joke. Sometimes the joke was on me." Former executive editor of the *Times* and retired president of St. Petersburg's Poynter Institute Bob Haiman said: "For most of our readers, [Dick] *was* the *St. Petersburg Times*. Dick was the bridge between the older staffers and the younger staff. He was the hardest working reporter on the staff. His column wrapped them in a blanket of good humor, nostalgia and eternal optimism. His cheer, optimism and good heart came through in his column. A reader once wrote me, 'I read Dick Bothwell first every morning to get the warm snugglies; then I turn back to Page One and face the bad news.'"

In 1917 John Richard Bothwell was born in Lead, South Dakota, the same year that "Buffalo Bill" Cody died. Perhaps for that reason

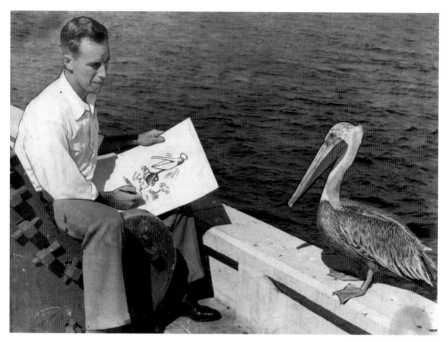

In one of his first undertakings as a weatherman with the *St. Petersburg Times,* Bothwell introduced Pelican Pete. *Courtesy June Bothwell Hinson.*

Bothwell always fancied himself a cowboy. In 1939 after serving with the Civilian Conservation Corps, Bothwell answered a *Time* magazine ad and landed the sole job in the *St. Petersburg Times* art department. He left Lead, forsaking the plains and outhouses stocked with Sears & Roebuck's catalogues. "I left the Black Hills for good, coming to Florida" for $17.50 a week, Bothwell told the *Times* in 1981. In one of his first undertakings as a weatherman, Bothwell introduced his alter ego J. Thundersquall Drip and Pelican Pete in cartoon form to readers. Pete claimed it to be cold everywhere but here. When temperatures dropped Bothwell, a man without a meteorology degree who consulted the National Weather Service, would predict a blanket-grabber of a night. "If you can tell [the reader] the floor is going to be cold on his feet, he can relate to that," Bothwell wrote in the *Times* in 1980. June Bothwell Hinson, who married the writer in 1947 after his army discharge, said, "That's what he was doing when we met. They assigned it to him. Weather wasn't his favorite, but he always brought humor to what he did."

After reading Bothwell's humorous bulletin board offerings at the *Times,* a cigar-chomping editor queried as to why this funny man

didn't write a column? Bothwell got his column, and in 1949 he introduced another alter ego, Kcid Llewhtob—Dick Bothwell spelled backwards. In the 1950s, Bothwell waxed creative and joined sixteen plumbing pieces together: faucets, float balls and all. He called his work *Man and his City,* and he said that all the parts could be removed without any concern that his creation would suffer any loss of beauty. In the early 1960s, an editor gave the name of Old Arab Turk to Llewhtob. The result in 1962, Bothwell later revealed, was the foundation and title of a new column: "O.A.T. (Of All Things)." "He would tell things that happened in our family," Hinson said. "Our travels to Paris, England, Italy and Canada were discussed. We'd be embarrassed. Everywhere we went he had his notepad. He would write and draw things and people. He did it more to pass the time than anything. He was marvelous at interviewing."

In 1975 Bothwell traced St. Petersburg's history and the lives of many of the city's renowned residents in his book *Sunrise 200.* His *Great Outdoors Book of Alligators and Other Crocodilia* still sells. "He made five cents a copy," Hinson said. "I'm still getting $80 to $100 a year in royalties." In 1978, Bothwell perked up reader's Mondays with his "B.U.M. (Brighten Up Monday)" column. "He'd again write about our travels, everything," Hinson said of her witty husband, a speed-reader. Leigh Dallas, one of two Bothwell children, said dinnertime was often spiced with her father's daily experiences. "Every night at dinner he would tell us about the people he talked to that day," said Dallas, who recalled that Bothwell was several times offered jobs as an editor and refused them because of his desire to write and interview. In 1979 and 1980, Bothwell had a multitude of his "B.U.M." columns published into books: *B.U.M. Stories.* When Bothwell spoke at the event to celebrate his fortieth anniversary at the *Times* in 1979, he was asked to comment on the future. "What of the future, people ask me," Bothwell said then. "Frankly I find it inviting, fascinating. Life is like the old cliffhanger serials. As a columnist I have a front row seat. There are two kinds of people—those who believe in time and aging and those who don't. I am a charter member of the latter group. As a great naval hero once declared on the eve of battle, 'I have only begun to write.'"

As a public speaker, Bothwell was in huge demand. His "Chalk Talks" series, during which he drew caricatures of audience members at civic and social meetings, were immensely popular. His "What's Wrong With Women" chats amused both men and women for decades from here to Key West. It was reported that later in his life he found himself entertaining the daughters of women he had addressed years before. "He

In 1975, Bothwell traced St. Petersburg's history and the lives of many of the city's renowned residents in his book *Sunrise 200. Courtesy June Bothwell Hinson.*

would say if women were smarter than men, they'd wear their zippers in front, not the rear," Hinson said. Roy Peter Clark, Poynter Institute's senior scholar, said Bothwell had "a finger on the pulse of an aging and transplanted community. He was interested in everyday human foibles." Bothwell often claimed with a straight face that he resembled actor Robert Redford. He sang at work, sold three-cent candy and told jokes he had stolen from numerous sources. He also hated asparagus. "It is a well-known fact that the Greeks and Romans, who lay around eating asparagus all day long, were wiped out, right?" Bothwell cautioned children to be aware of "that green flabby weed," saying, "almost no one who has died has not eaten asparagus." Said Wilbur Landrey, former *Times* foreign editor: "[Bothwell] brought humor into the newsroom. Not a malicious bone in his body."

On January 30, 1981, Bothwell dressed as a cowboy and entertained his fellow workers by frolicking in the newsroom and twirling a lariat. The next day Bothwell awoke at 6:00 a.m. feeling uncomfortable. The Christian Scientist prayed for thirty minutes, and then he died. "We had taken a stand," Hinson said. "We weren't going to go any medical route." That morning a Christian Scientist practitioner came. He and Bothwell's wife prayed for an hour, hoping Bothwell would revive. "It was one of the worst days of my life," said the former journalist Bob Haiman, who that morning saw Bothwell lie motionless in his favorite chair. It was later determined medically that Bothwell died of natural causes. The next day the *Times* ran a blank space where Bothwell's column normally appeared, listing his name and his dates of birth and death. In a space nearby, a poignant message said that Bothwell's cluttered desk would later be neatened and occupied by someone else. It would never, however, be as bright as before. "Nobody around our building even considered that Dick Bothwell might die," wrote *Times* sports editor Hubert Mizell in 1981. "Surely he was immortal. A man to outlive Methuselah. He would be around at 101, still walking without a stick around a sunny, sandy swatch of Earth that to him was heaven."

After Bothwell's death there was a public outcry of sympathy that measured more than three hundred strong. Readers traveled to the *Times* to express their grief. Others wrote letters that cascaded like an avalanche into the newspaper. Published in the *Times* that February in 1981 were some of those letters, including one from reader Diane Daniel: "I picked up the *Times* from my driveway and tears began to flow before I could reach the front door." Resident Eleanor N. Pfluke wrote as a person who had lost someone extremely close to her. "I feel I have lost a member of my own family."

The James Weldon Johnson Branch Library: The Dawn of True Freedom

On the plantation, it was against the law to teach a slave to read. We ain't on the plantation anymore.

Activist Kevin Johnson

Before the Carnegie Library opened here in 1915, benefactor Andrew Carnegie hoped the facility would serve every St. Petersburg resident. It didn't turn out that way. "It was against the law for black people to go into a library," said local activist Kevin Johnson about the ordinance that established the policy. And with the city's only black school—Davis Elementary—sans a library, blacks were deterred from additional enlightenment. That prejudice prevented many blacks from achieving intellectual fulfillment here for thirty-two years. The opening of the James Weldon Johnson Branch Library helped to end that medieval period of frustration. Since its inception in 1947, the Johnson Branch has experienced relocation and reconstruction. All the while, it has served as a beacon of education to the black community. "The library is like an icon," said Mary Gaines, a former Johnson Branch librarian and now St. Petersburg's library system director. "It represents history. It was the first library African Americans could identify with."

In 1915, tycoon Andrew Carnegie donated $17,500 to establish the Carnegie Library at Mirror Lake—the city's first library facility. The firm hand of segregation, however, ruled the area. The city's green benches were off-limits to blacks; restaurants turned them away. And despite Carnegie's wishes, the library refused blacks exposure to its 2,600 volumes. At the Campbell Park Center, a reading room provided blacks with their only access to books. It wasn't until 1944 that talk surfaced regarding a black library. Mrs. S.M. Carter, wife of the First Baptist Institutional pastor, led the drive. While negotiations proceeded, the city eased its position and granted blacks admission

The $2.7 million James Weldon Johnson Library was dedicated on September 28, 2002, at 1059 Eighteenth Avenue South. A state grant and Penny for Pinellas paid for the $3.8 million project, which included land. *Courtesy St. Petersburg Museum of History.*

into the Carnegie Library's basement. "People are uncomfortable with libraries anyway, overwhelmed with information," said Paula Ivory, a former Johnson Branch librarian. "Combine that with the feeling that you weren't wanted."

By December 18, 1945, Carter's interracial committee had met with then-City Manager Carleton Sharpe, the *Evening Independent* and the *St. Petersburg Times.* "Mrs. Carter was the guiding light for the project, and her determination to get a library was influential in the city's action to make an appropriation," Pamela Peterson, another former Johnson Branch librarian and now the library system's acquisition technician of services coordinator, wrote in an April 21, 1998 memo, preserved at the St. Petersburg Museum of History in this author's file. In 1947 after a funding of $3,500, the library was dedicated on April 1. Its 1,066 volumes filled a 1,025-square-foot room inside a black Masonic lodge. The city leased the room from the lodge at 1035 Third Avenue South for $50 monthly. "It was a room," Iveta Berry, former president of the Campbell Park Neighborhood Association, told the *Times* in 2002. "There were few tables or chairs. It was more like a bookstore-type thing. But to us it was dynamite, A-No. 1." Inspired by his poetry and

writing, Carter's committee named the library after civil rights leader and Florida native James Weldon Johnson. Johnson, born in 1871, also had written the black national anthem "Lift Every Voice."

Former Gibbs High School librarian Lessie Burke became the facility's first librarian. Helen Edwards, who ran the library for more than three decades, replaced Burke in 1950. Edwards established book reviews and held children's story hours. The library opened from 1:00 to 5:30 p.m. and 6:00 to 8:00 p.m. Monday, Tuesday and Thursday. On Wednesday and Saturday, the hours were 9:00 a.m. to 12:00 p.m. and 1:00 to 5:30 p.m. At one point, the collection expanded to 2,789, and there were 1,821 registered patrons. "The building was closed on Fridays and Sundays, but on the evenings it was open there was standing room only with sixty-five to seventy people," Peterson, who amassed her information from old news articles, wrote in her April of 1998 memo.

During the Gas Plant area redevelopment in 1979, the library closed. It reopened inside the Enoch Davis Center at 1111 Eighteenth Avenue South on October 6, 1981. The center is named after local civil rights leader Reverend Enoch Davis. With Edwards as librarian, the Johnson Branch boasted the largest black author collection in Florida. Edwards retired in 1984 and was succeeded by Mamie Doyle Brown. "[Edwards] left behind a legacy that endures to this day, and inspired many children who used the library," Peterson added in her 1998 memo, "instilling in them a love of the library, and making sure they developed the skills to use it."

As interim librarian in 1990, Mary Gaines reorganized the facility's volumes. She also isolated the black authors section before Peterson's appointment as librarian the next year. "It took six months to organize the black titles," said Gaines, who also worked at the North Branch Library at the time and was then the city's only black librarian. "The kids [aged six to eleven] helped out." In 1990, however, rumors abounded that the city was going to slash funding and close the library. In response, activist Kevin Johnson organized the James Weldon Johnson Friends of the Library Inc. and circulated petitions to save the facility. "I was on street corners, in churches and on the phone four to five hours a day after work," said Johnson, no relation to the library's namesake. "The young in the community did so much to help. We had fifteen-hundred people sign the petition" to save the library. Former Johnson librarian Ivory added: "So many [patrons] say that they didn't know the library was here. Once they're here they come back. This can be a real refuge for them. They feel this is home. But we're out of room." About 1990 the Enoch Davis Expansion Task Force was established, chaired by

Ernie L. Coney, current president of the Friends of the James Weldon Johnson Branch Library. Coney said: "[Kevin] Johnson almost single-handedly got everyone involved. We kept the pulse of the community involved in this thing. The city realized we weren't going to stand by and lose our library." The task force strove to "develop and enact a plan of expansion of the current physical structure…so that the building will have functional structural integrity," established the *Mission Statement of the Enoch Davis Expansion Task Force*, preserved at the St. Petersburg Museum of History in this author's file.

The task force's dream materialized on September 28, 2002, when changes were made in the center and a new 14,200-square-foot James Weldon Johnson Branch Library was dedicated. For Coney, the moment was bittersweet. "It irks me that not even a plaque was drafted to honor the efforts of the Task Force," he said. Mayor Rick Baker, several city council members and a standing room only crowd witnessed the dedication; Kevin Johnson spoke while fighting back tears. "On the plantation, it was against the law to teach a slave to read," he said according to a 2002 *Times* piece. "We ain't on the plantation anymore." According to Kevin Johnson, the triumph was a catalyst for the library system because it forced city officials to closely monitor annual budgets.

The $2.7 million library at 1059 Eighteenth Avenue South neighbors the Enoch Davis Center. A state grant and Penny for Pinellas paid for the $3.8 million project, which included the land. The facility features computer, meeting, study, story hour and conference rooms. Some 40,500 books, videos and magazines fill the library. The Pinellas Public Library Cooperative issued a $300,000 grant that paid for thirty computers. "The new library is an accomplishment," Kevin Johnson later said. "The community should be proud. It's continuing a great legacy. It makes me feel that what I did was worth it. The community needs to pat themselves on the back." More recently, the Johnson Branch has befriended Head Start and other children's services. It has conducted summer reading programs and coordinated activities with the Enoch Davis Center. It will soon expand to house an additional 10,000 volumes. Said Johnson Branch librarian Allison Gunther-Blackman: "It's been very heartwarming. There are constant lines of patrons. In the future, there will be improvements that I'm looking forward to."

James Rosati Sr.:
The Duke of Construction

Mr. Rosati and his sons have pioneered a new era in housing for the disabled. Not only in this country but throughout the world.

Dr. Howard A. Rusk, 1960

Throughout St. Petersburg's building boom of the 1950s, developer James Rosati Sr. reigned over the construction game. He was energetic, often building homes at a breathtaking pace. He was innovative, often leaving his competitors buried under a mountain of construction firsts. He sported such style and grace that many called him elegant. Friends just called him the Duke, "because he prowls muddy projects in royal raiment, never having switched costumes when he left the men's suit business for construction," local journalist Douglas Doubleday wrote of Rosati Sr. in the *St. Petersburg Times* in 1961.

Before Rosati's arrival here in 1950, no one had drained land and built homes on large fringe tracks. When Rosati began building homes amid orange groves the industry first chuckled—they then followed suit. Rosati inspired concrete house construction and developed St. Petersburg's first post-Depression subdivision. In 1950, Rosati's Tyrone Gardens garnered the National Association of Home Builders' (NAHB) first place award. His Orange Lake Village was featured in 1957 on an NBC TV thirty-minute program. Rosati's Skyview Terrace earned him the *Florida Illustrated* community award. By the 1960s, Rosati was building five hundred houses a year and had already won numerous honors. In 1960, Rosati netted the Award of Merit for his Horizon Home for the disabled from the American Institute of Architects. In Chicago before the general assembly of NAHB members in 1961, Rosati accepted *Practical Builder Magazine*'s "Oscar"—the highest construction honor in the country. "Rosati is recognized as one of the nation's leading home builders, and the unchallenged retirement home

When James Rosati Sr. began building homes amid orange groves, the industry chuckled but followed suit. Rosati developed St. Petersburg's first post-Depression subdivision. *Courtesy James Rosati Sr.'s family.*

producer of the Florida West Coast," wrote Lynn B. Clark for *Women's Day* magazine in the early 1960s.

In 1898, James Rosati Sr. was born in New York City. He finished his education and entered his father's clothing business, subsequently

affiliating himself with a successful men's suit manufacturer as a jobber. As the 1920s unfolded, Rosati became less and less enthused about men's apparel. He ventured into his own plastering concern, which led him to later manage an enterprise as a plastering contractor. Subsequently, Rosati assisted cities and contractors in metropolitan Long Island with highway construction. About 1923, Rosati married Ida Manieri. "He gave us a wonderful life," said Genevieve Binda, Rosati's eldest of three children. "He wore a smoking jacket every night. Sat next to me and taught me how to read." James Rosati Jr., the spitting image of his father, who was five feet seven and featured a medium build and dark hair, said: "He always wanted to teach us things and always wore a nice suit and dressed well."

During World War II while under government contract, Rosati built more than 600 Norfolk, Virginia, apartments for servicemen and shipyard workers. He returned to the Big Apple after the war and was given the project of clearing the land for Idlewild Airport. It was reported that while on the several-year airport assignment, Rosati initiated a technique to move the homes while they were completely intact. At age fifty in 1948, Rosati came to Tampa and began the city's 396-home Bel Mar Gardens. The developer then built 41 more homes in Tampa to create Treasure Garden. In 1950, Rosati relocated here and initiated construction on the 400-home Tyrone Gardens, the first new home development in St. Petersburg in two decades. Near the development, Rosati built the city's first post-World War II shopping center. "Rosati was very successful," said surveyor C. Fred Duel, who worked with Rosati on Tyrone Gardens and other developments. "An honest builder who knew how to market his developments." By 1954, Rosati had launched Oak Valley Estates (100 homes at Sixty-seventh Street and Eighth Avenue) and Orange Hill (196 homes at Forty-ninth Street and Fifty-fourth Avenue North). Orange Hill was the west coast of Florida's first development set amid an orange grove.

In 1954, Rosati began developing Orange Lake Village near Lake Seminole. After he carved the village into 1,026 lots, it reportedly became the nation's first retirement village of homes. For $2 monthly, residents enjoyed perks including swimming and shuffleboard at Orange Lake's community center. "Dad was an innovator," said Rosati's son Joseph. "He felt that residents would rather live in a sturdy home constructed of cement blocks rather than a trailer. A one-bedroom, one-bath home with a carport sold for $5,995; a two-bedroom, one-bath with carport sold for $7,250." By 1956, Joseph and his brother James Jr. had joined Rosati as vice-presidents. The three developed the 1,600-home, 402-acre Skyview Terrace in 1958 on U.S. 19 and Forty-ninth Street in

Pinellas Park. "I'm shooting for first prize in low-cost housing," Rosati told the *Evening Independent* that year. "Shooting the works. I'm going to build fifty houses to start. There will be five to eight models. Three types of driveways: circular, straight and some with turnarounds. Think of it, fifteen thousand cars a day are using that highway. What a location."

Florida Retirement Village, the home of Rosati's Horizon Home for the disabled, was later added to Skyview. The Horizon Home's highlights trumpeted low-level faucets and wall switches for the disabled. The home's design featured unfettered access to every area to those in a wheelchair. Hard-to-navigate corners were nonexistent. Appliances were placed low for easy access, and coffee tables could raise and lower. Built-in vacuum cleaners offered easy accessibility and operation. With wheelchair-bound baseball great Roy Campanella and stockbroker and presidential advisor Bernard Baruch beside him in 1960, Rosati presented a model Horizon Home to Belleview Medical Center in New York. The site of the home, which still stands adjacent to the center today, was valued then at millions of dollars.

"Roy, please cut the ribbon to this home, a home that will bring new opportunities to millions of people in the world," the *Times* quoted Dr. Howard A. Rusk as saying in 1960. Dr. Rusk was then the director of the Institute of Physical Medicine, New York University Medical Center. "By their vision and generosity," Dr. Rusk continued, "Mr. Rosati and his sons have pioneered a new era in housing for the disabled. Not only in this country but throughout the world." In the early 1960s the father of President John F. Kennedy, a disabled Joseph P. Kennedy, moved into Rosati's New York City Horizon Home. "Joseph P. Kennedy, the president's ailing father, now recuperates in the care of specialists, in a neat, concrete-face, flat-roofed home, that stands on an incredible green-lawned patch of suburbia, tucked away among the skyscrapers of Mid-Manhattan," wrote local journalist Paul Davis in 1962 for the *Independent*.

In 1961 Rosati suffered a broken leg, arm and ribs when a train collided with his car. The tragedy took Rosati's cousin's life. Later that year, the Rosatis opened Freedom Village at U.S. Alternate 19 and Ninety-second Avenue North. For $13,750, residents could own the Heritage—a two-bedroom, one-bath home with a garage. The Liberty—featuring three bedrooms, two baths and a garage—sold for $14,950. Before his death at age sixty-five in 1967, Rosati had built more than five thousand homes here and created seven major subdivisions countywide. "He went into great depth and detail to answer construction questions," said James Jr. "[Construction] was his love."

116

Norman E. Jones:
A Voice of Controversy

I am convinced that in most communities, [Jones will] *be in danger of his life.*
 Congressional candidate Andrew Young, 1972

In 1973, black publicist Norman E. Jones refused to retreat from his anti-integration stand. "Right," he said, according to a 1972 *Wall Street Journal* piece. "I don't believe in the Easter Bunny, Santa Claus or the tooth fairy, and I have my doubts about the Great Pumpkin. I don't believe in integration because it is another fantasy. Two forces can't integrate without destroying them."

From 1950 to 1990 Jones frustrated black and white liberals here and across the nation, offering them endless debate. He trumpeted the concepts of Marcus Garvey, Booker T. Washington and George Washington Carver, but he found W.E.B. Dubois's heavy emphasis on education shallow. He described Martin Luther King Jr. as a black leader chosen by the white press. While some blacks saw busing as a positive issue, Jones backed the Parents Against Forced Busing. In 1968 and 1972, Jones supported Alabama Governor George Wallace for president. "[My father] realized that American society is all about economics, money," said Norman E. Jones II. "He often questioned the value of being allowed in a restaurant you can't afford to enter." For forty-two years, Jones was a photojournalist. He spent twenty-eight years as a booking agent, promoter, road manager and performer. For more than five years Jones had a Tampa Bay radio show, later hosted a locally televised political talk show and established his own public relations and sales promotion agency. Some saw Jones as a vibrant St. Petersburg personality; others shunned him. Some called him a genius; others sided with 1970s activist and present chairman of the NAACP Julian Bond, who in a 1972 *St. Petersburg Times* article called Jones "an opportunist at

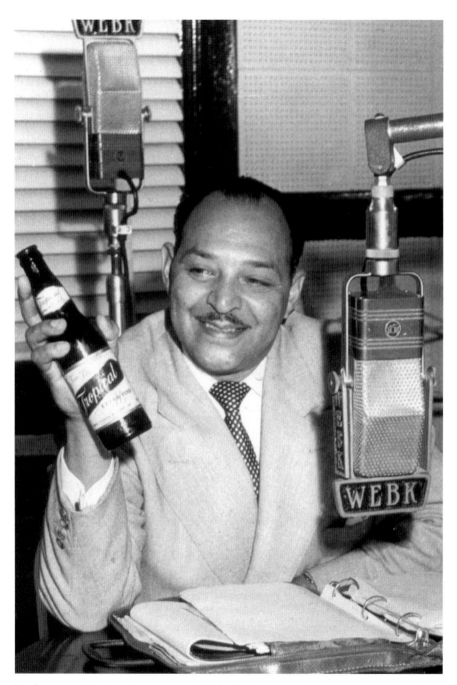

In the 1950s Norman E. Jones established the *Norman E. Jones Down on Central* radio program, which ran on WEBK for more than five years. *Courtesy Norman E. Jones II.*

best, a political whore at worst." But despite what people thought about Jones, a self-proclaimed "Black Don Quixote," he inspired thought. "If he saw something wrong, he spoke about it," said retired local tailor Angres Chapman, who knew Jones from 1978 to 1990. "He didn't run away from anything. A busy guy. All over the place."

Born in 1909 in Lawrence, Kansas, Jones was the second of four sons of a farmer and mechanic. Farming, shining shoes, selling ice cream and setting bowling pins occupied Jones's time as a youth. He attended California elementary schools, where he lived with relatives after his mother's death. Once back in Kansas City, Jones enrolled in Lincoln High School's first black history course in 1925. "Negro, Colored, African-American and Black, is the most colorful history of all the people in America," Jones said in a letter to several universities, preserved in the Norman E. Jones file at the University of South Florida St. Petersburg. During and after high school, Jones waited tables and practiced photojournalism. He later attended Henderson Business College in Memphis, Tennessee, where he became a protégé of Professor George W. Henderson. Jones studied philosophy, sales and religion and began to question W.E.B. Dubois's sole emphasis on education to achieve civil rights. "[Dubois] had men who had made fortunes in the building trades denounce their fields," wrote the rotund Jones in his essay *Black Intelligentsia*, preserved in the Norman E. Jones file at the University of South Florida St. Petersburg. "Rich and successful farmers drove their sons out of farming so they could get a white collar job."

From 1930 to 1939, Jones worked as a booking agent with the Theatre Owners Booking Agency. About 1939, Jones married Clora Nellie Graves Robinson in Memphis. They had three children. As a family man Jones continued with photojournalism and worked as a bartender, hotel bellman and public relations director for the Improved Protective Order of the Elks of the World (1941 to 1948). About 1948, Jones helped found the National Negro Marketing Association and separated from his wife. In Tampa about 1950, Jones became the Central Life Insurance Company's public relations director. By 1953, he had bartended at the Cotton Club and served as Tampa's first black new car salesman. Jones had also established the *Norman E. Jones Down on Central* radio program, which ran on WEBK for more than five years. "He had a jovial but aggressive personality," said former teacher Mordecai Walker, who knew Jones in Tampa. "He would come on with a statement that would catch your attention." Before Jones came to St. Petersburg in 1959, he initiated the Norman E. Jones Agency and Publicist, which assisted a majority of black clients.

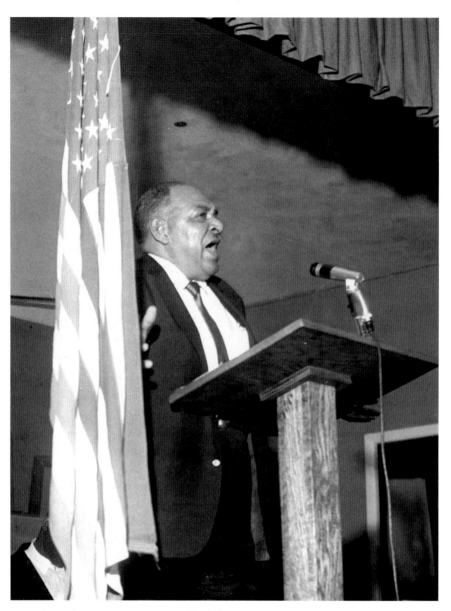

In 1968 and 1972, Jones supported Alabama Governor George Wallace for president. *Courtesy Norman E. Jones II.*

Jones, whose eloquent voice and thrashing arms captivated people as clouds of cigar smoke blanketed his face, initiated a concept of the intense training of blacks in the field of sales nationwide in the 1960s. The company-subsidized program would increase black dignity and the gross national product, Jones felt, and crime and relief payments would plummet. Most blacks joined hands with the civil rights movement, however, and Jones's sales concept stalled. "Oddly enough, there is a reluctance to use…public relations, advertising, sales, promotion" to combat poverty, Jones wrote in his essay *War on Poverty*, preserved in the Norman E. Jones file at the University of South Florida St. Petersburg. "In a…capitalistic society, nothing—absolutely nothing—happens until somebody makes a sale." Amid the civil unrest of the 1960s, Jones condemned politicians who backed the movement for self-serving reasons. He said law enforcement was leading us into a police state, and civil rights organizations were offering little change. In 1966, Jones established his "Let's Talk Politics" column in several black Florida newspapers. The column ran for nearly eight years and focused on civil rights and capitalism. "Black Historians certainly did a thorough emasculation job on blacks who made outstanding contributions under [capitalism]," wrote Jones, then married to Mary Louise Brayboy (1960). "Black economic pioneers were deliberately left out. The advice…of the greatest of all Black leaders, Booker T. Washington, [was ignored]."

After serving as editor for the *St. Petersburg Times Negro Page* (1963), Jones entered the 1968 Democratic race for U.S. Senate, challenging former Florida Governors LeRoy Collins and Farris Bryant. Jones said he held degrees from many street universities nationwide, including the "University of Harlem. I expect no contributions from special interests…and will be the only candidate free of conflicts of interests," Jones told the *Times*. Lack of funds ended Jones's Senate race, however. He later founded the Florida West Coast Chapter of the American Marketing Association, was a public relations director of the Florida Voters League and a Wallace backer for president in 1968. From July through September in 1969, Jones hosted a thirty-minute color television program on WTOG, channel 44. *Tell It Like It Is* ran on Sunday nights at 11:15 p.m., following the *CBS News with Harry Reasoner*. Jones and his guests of local and state importance discussed news and its relevance to blacks. Topics included civil rights, organized labor and the Wallace presidential campaign. Jones garnered national attention in 1972 by stumping for Wallace in Florida, Maryland, Michigan and Indiana.

At age sixty-three that year as chairman of the National Black Citizens for Wallace, Jones served as a Wallace delegate at the Democratic National Convention. C. Bette Wimbish, a black St. Petersburg City Council member, joined him. Jones believed Wallace supported working-

class blacks, and he considered the backing of Wallace his political highlight. Not everyone agreed. "I think this Jones guy is nuts," the *Wall Street Journal* in 1972 quoted Andrew Young, then a Congressional candidate from Atlanta. "I am convinced that in most communities, he'll be in danger of his life." Today, the Reverend Wayne Thompson of the city's Baptist Institutional Church sees those days differently. "Folks thought [Jones] was a bit conservative," Thompson said. "But time has shown that he was pretty much in line." After Wallace's loss, Jones had a stroke and dropped his "Let's Talk Politics" column. He closed his public relations office.

In 1974, numerous local black dignitaries gathered at the Don CeSar Hotel to roast Jones. Ernest Fillyau, later a St. Petersburg Council member, called Jones that night a "man ahead of his time." On February 28, 1990, Jones suffered a second stroke. His kidneys later failed, and on August 13 he died at Bayfront Medical Center at age eighty. For some, the words Jones spoke to the *Florida-Sentinel Bulletin* in 1990 still echo. "Integration is a phony, and all those who promote it are phonies. They're benefiting some way." In 2001, Norman E. Jones II placed his father's papers and audiotapes in the University of South Florida St. Petersburg's archives. By 2003, the Norman E. Jones Work of Arts Center had been featured in the Sunshine City. Later the Norman E. Jones Black History Exhibits were displayed at the St. Petersburg Museum of History and then the Johnson and Mirror Lake Libraries.

Selected Bibliography

Manuscripts and Document Collections

Baynard, Fay. Speech, November 4, 1993. St. Petersburg Museum of History—Scott Taylor Hartzell file.

Caldwell, Robert W. Brochure, 1941. St. Petersburg Museum of History—Scott Taylor Hartzell file.

————. Financial notes, 1950. St. Petersburg Museum of History—Scott Taylor Hartzell file.

Enoch Davis Expansion Task Force Mission Statement. St. Petersburg Museum of History—Scott Taylor Hartzell file.

Goldman, Mayor Herman. Letter, December 6, 1961. St. Petersburg Museum of History—Scott Taylor Hartzell file.

Jones, Norman. *Black Intelligentsia*. University of South Florida St. Petersburg—Poynter Library.

————. Letter to the universities. University of South Florida St. Petersburg—Poynter Library,

————. *War on Poverty*. University of South Florida St. Petersburg—Poynter Library.

Peterson, Pamela. Memo regarding the James Weldon Johnson Library. St. Petersburg Museum of History—Scott Taylor Hartzell file.

Ponder, Ernest A. Lecture. St. Petersburg Museum of History—Scott Taylor Hartzell file.

Sherman, Peter. Letter, November 1, 1962. St. Petersburg Museum of History—Scott Taylor Hartzell file.

Newspapers and Periodicals

Evening Independent
Florida Sentinel Bulletin
Fort Myers News-Press

Gulfport Tribune
St. Petersburg Times
Tourist News
Wall Street Journal

Books

Arsenault, Raymond. *St. Petersburg and the Florida Dream, 1888–1950*. Gainesville: University Press of Florida, 1996.

Fuller, Walter P. *St. Petersburg and Its People*. St. Petersburg: Great Outdoors Publishing Company, 1972.

———. *This Was Florida's Boom*. St. Petersburg: Times Publishing Company, 1954.

Grismer, Karl H. *Akron and Summit County*. Akron, OH: Summit County Historical Society, 1957.

———. *History of St. Petersburg, Historical and Biographical*. St. Petersburg: Tourist News Publishing Company, 1924.

———. *Story of St. Petersburg*. St. Petersburg: P.K. Smith and Company, 1948.

School Board of Pinellas County. *A Tradition of Excellence*. St. Petersburg: School Board of Pinellas County, 1987.

Shank, Claire Brown Williams. *The President's Book and a Brief History*. St. Petersburg: St. Petersburg Woman's Club, 1981.

Straub, William L. *History of Pinellas County, Florida*. St. Augustine: The Record Company, 1929.

Index

A

Admiral Farragut Academy 31
Albert Whitted Airport 81, 82, 83
Allen, George C. 32
Allen-Fuller Corporation 32
Atkins, Luther 27
Atlantic Coast Line Railroad 26

B

Baker, George "Ted" 83
Bank Nights 65, 67
Bannister, F.C. 27
Barco, Paul 21
Bat 83
Beasley, Irene 22
Blanc, Robert 35
Board of Trade 25
Bond, Julian 117
Bothwell, Dick 35, 68, 89, 103, 105, 107
Brown, Lew B. 25
Brown, Mayor John 82
Bryant, Judy 28

C

Caldwell, R.W., Jr. 95
Caldwell, R.W., Sr. 93
Campbell Park 71
Campbell Park Center 109
Campbell Park Elementary 23
Carnegie, Andrew 109
Carnegie Library 109
Carreno Music Club 75, 77

Carver, George Washington 117
Chiles, Governor Lawton 52
Clark, Roy Peter 107
Clarke, Dr. Johnnie Ruth 37
Coca-Cola Building 55
Collins, Governor LeRoy 56, 101
Coney, Ernie L. 112
Cook, Marguerite 82
Cribbett, James 19

D

Davis, F.A. 45
Davis, Ned 19
Davis, Reverend Enoch 111
Davis Academy 19, 20, 21, 49
Davis Elementary 19, 21, 22, 23, 49, 109
Detroit Hotel 46
Dill, Glen 87, 89, 91
Disston, Hamilton 35
Dreier, Thomas 99, 101
Dubois, W.E.B. 117, 119

E

Edison, Thomas Alva 59
Enoch Davis Center 111, 112
Enoch Davis Expansion Task Force
 111, 112

F

Fansler, Percival Elliott 25
Fillyau, Ernest 122
Florida Federation of Women's
 Clubs 15

Florida General Federation of
 Woman's Clubs St. Petersburg
 Juniorettes 17
Florida Presbyterian College 79, 99, 102
Florida Theatre 65, 68
Friends of the Library 99, 101, 102, 111
Fuller, H. Walter 31
Fuller, Walter P. 20, 31, 45, 59

G

Gable, Dr. N.W., Jr. 53
Gandy, George "Dad" 25
Gangplank Nightclub 31
Garvey, Marcus 117
Gibbs, Jonathan C. 70
Gibbs's St. Cecelia Choir 51, 71
Gibbs High School 21, 39, 49, 51,
 69, 111
Goldner, Mayor Herman 10, 75, 102
Goodyear blimps 81
Goodyear Tire and Rubber Co. 83
Greeley, Ashford 66
Greene, Nancy 13
Grismer, Karl H. 43
Gulfport 11, 93, 95, 96
Gulfport Tribune 93, 97

H

Hall, Charles A. 25
Hanna, Roy 45
Helen Roberts Scholarship Fund 77
Hollins, Dixie 96
Holmes, Ella Mary 21, 49, 52, 70
Horizon Home 113, 116

J

James Weldon Johnson Branch Library
 109, 112
Jannus, Anthony Habersack 10, 25, 82
Jessel, George 67
Johnnie Ruth Clarke Center 40, 41
Johnson, James Weldon 109, 111, 112
Johnson, Kevin 109, 111, 112
Jones, Norman E. 117, 119, 121, 122
Jonesberg, Frank F. 15

Jungle Country Club Hotel 31, 33
Jungle Prada 31, 33

K

King, Martin Luther, Jr. 117
Kreutz, Oscar 79
Kuttler, Dr. Karl M., Jr. 37

L

Lakewood High School 49, 51
Latham, Bird Malcolm 29
Lodwick, John 83

M

Mayflower 83
McKinney, Theresa 71
McLin, O.B. 39, 69, 73
McQueen, Roberta 19, 22
Mercy Hospital 41
Methodist Town 49
Mitchell, Noel 25
Mound Park Hospital 16, 57
Municipal Pier 27
Muskie, Edmund S. 40

N

NAACP 72, 117
National Airlines 81, 83
National Guard 53, 55, 56

O

Ovaltree, J.W. 19

P

Pass-a-Grille 32
Peabody, Mae 29
Pearce, R.S. 67
Perkins, George W. 71
Peterman, Peggy 20
Pheil, A.C. 27, 82
Phinney, A.H. 45
Pigeon Roost 67
Pinellas County 34, 40, 51, 52, 53, 69,
 70, 71, 73

Index

Pinellas County Medical Society 53, 55
Piper-Fuller Flying Field 33
Plant, Henry 46
Playford, Harry 85
Ponder, Dr. Ernest A. 49, 69
Ponder, Fannye 39, 49
Ponder, James Maxie 49
Poynter, Nelson 89
Poynter Institute 103, 107
Presley, Elvis 67, 90
Pulver, Frank Fortune 39
Puritan 83

R

Rand, Sally 67
Reed, Harrison 70
Reed, Ralph 35
Resolute 83
Rex MacDonald's Silver Kings 67
Roberts, Helen Dearse 75, 77, 78
Roberts Music Center 77, 79
Roberts Youth Center 77
Rogers, Will 28, 103
Roosevelt, Franklin Delano 33
Rosati, James, Jr. 115, 116
Rosati, James, Sr. 113
Rosati, Joseph 115

S

Sharpe, City Manager Carleton 110
Shelton, Perkins T. 37
Snell, C. Perry 13, 15, 25
Sommers, J. Harold 45
South Pacific 67
Spicer, Mayor Don 79
Springstead, Kittie H. 81
St. Anthony's Hospital 57, 75, 78
St. Petersburg Board of Realtors 93, 97
St. Petersburg High School 32, 70
St. Petersburg Junior College 35, 37
St. Petersburg Multiple Listing Service
 Inc. 97
St. Petersburg Museum of Fine Arts
 59, 64

St. Petersburg Museum of History 7,
 14, 28, 51, 61, 70, 77, 93, 97,
 110, 112, 122
St. Petersburg Orange Band 66
St. Petersburg Symphony 75, 78, 79
St. Petersburg Times Negro Page 121
St. Petersburg Woman's Club 13, 75
St. Pete Beach 32, 90
St. Raphael's Catholic School 79
Starkey, Jay 35
Stead, Rexford 64
Stewart, Emanuel 21, 49, 51, 69, 72
Straub, W.L. 45, 81
Stuart, Margaret Acheson 59, 63
Sunken Gardens 55

T

Thirty-fourth Street Colored School 70
Thompson, Mayor Judge Arthur 15
Thompson, William G. 22
Times's Medical Forum 56
Tin Gods 67
Tippetts, Katherine Bell 32
Torrio, Johnny 33
Tourist News 43, 45, 46
Tyrone Gardens 113, 115

U

University of South Florida St.
 Petersburg 8, 91, 119, 121, 122

V

Vigilant 83
Villa, Francisco 53

W

Wallace, Governor George 117
Washington, Booker T. 117, 121
Whitney, L.A. 25
Whitted, Lieutenant James Albert 82
Williams, Horace, Jr. 85
Williams Park 21
Wimbish, C. Bette 122

Windom, Ross 85
World War I 13, 15, 29, 32, 34, 53, 55
World War II 51, 115
WSUN radio 31
WTSP 87, 89, 90
Wysinger, Ruby 69, 71